Cool Restaurants Paris

2nd edition

teNeues

Imprint

Editors: Désirée von la Valette, Martin Nicholas Kunz

Editorial coordination: Katharina Feuer, Valerie Schmidt, Katharina Lange

Photos (location): Bruon Shacht (6 New York), Thomas Duval (Alain Ducasse au Plaza Athénée), Claude Weber S.22 (The Cristal Room Baccarat), Heuduck / RESO (Biotifull Place), courtesy Café de l'Homme (Café de l'Homme on front cover), Pep Escoda (Café Marly, Costes, Georges, Kong, Le Murat, Maison Blanche), Yann Deret (La Cantine du Faubourg, food), courtesy Le Train Bleu (Le Train Bleu, food), Anne Wencélius (Maison Blanche, food), enzo (Mandala Ray, food). All other photographs by Roland Bauer

Introduction: Sean Weiss

Layout & Pre-press: Katharina Feuer, Jan Hausberg

Imaging: Jan Hausberg

Translations: SAW Communications, Dr. Sabine A. Werner, Mainz
Ulrike Brandhorst (German / introduction), Elena Nobilini (Italian), Brigitte Villaumié (French), Silvia Gómez de Antonio (Spanish), Nina Hausberg (German, English / recipes)

Produced by fusion publishing GmbH, Stuttgart . Los Angeles www.fusion-publishing.com

Published by teNeues Publishing Group

teNeues Book Division
Kaistraße 18
40221 Düsseldorf, Germany
Tel.: 0049-(0)211-994597-0
Fax: 0049-(0)211-994597-40
E-mail: books@teneues.de

Press department:
arehn@teneues.de
Phone: 0049-2152-916-202

www.teneues.com

ISBN-10: 3-8327-9129-9
ISBN-13: 978-3-8327-9129-2

teNeues Publishing Company
16 West 22nd Street
New York, NY 10010, USA
Tel.: 001-212-627-9090
Fax: 001-212-627-9511

teNeues Publishing UK Ltd.
P.O. Box 402
West Byfleet
KT14 7ZF, Great Britain
Tel.: 0044-1932-403509
Fax: 0044-1932-403514

teNeues France S.A.R.L.
4, rue de Valence
75005 Paris, France
Tel.: 0033-1-55766205
Fax: 0033-1-55766419

teNeues Iberica S.L.
Pso. Juan de la Encina 2–48,
Urb. Club de Campo
28700 S.S.R.R. Madrid, Spain
Tel./Fax: 0034-91-65 95 876

Bibliographic information published by Die Deutsche Bibliothek.
Die Deutsche Bibliothek lists this publication in the Deutsche Nationalbibliografie;
detailed bibliographic data is available in the Internet at http://dnb.ddb.de.

Average price reflects the average cost for a dinner main course without beverages. Recipes serve four.

Contents Page

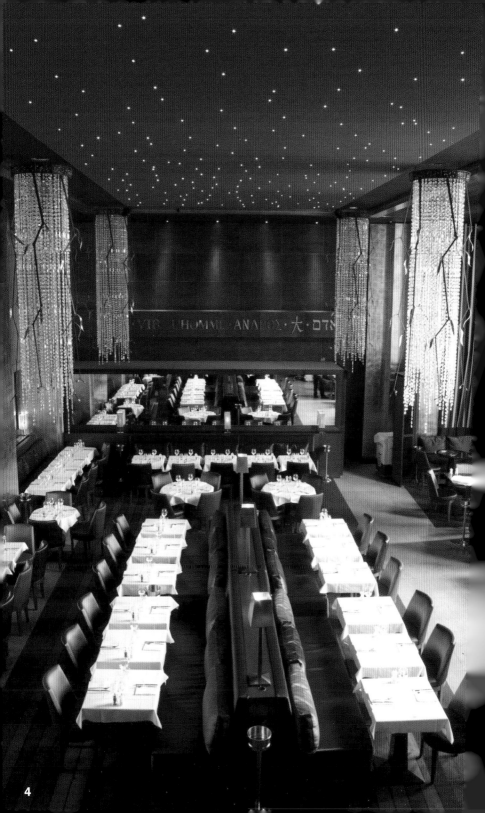

Introduction

Paris a vu naître les restaurants. Après la révolution, les meilleurs chefs du pays n'étaient plus dans l'obligation de servir les familles d'aristocrates. Aussi firent-ils profiter tout Paris de leurs délices culinaires : ils se mirent à servir dans de petits cafés avec des tables individuelles des mets recherchés. Cette tradition a favorisé le développement de la florissante restauration parisienne, synonyme d'innovation dans la Haute Cuisine.

Les restaurants parisiens les plus progressifs sont axés sur une synergie de la culture et du commerce. Les précurseurs de cette tendance sont les Frères Costes qui sont parvenus à rendre un art culinaire sans prétention très à la mode dans toute la ville. Leur restaurant Georges – qui surplombe la ville dans le Centre Pompidou – offre une vue fabuleuse sur Paris. Si vous êtes plus terre à terre, allez voir les autres restaurants des Frères Costes : au Café Marly au Louvre vous pouvez déguster une pâtisserie de Lenôtre et bénéficier de la vue sur la pyramide en verre d'IM Pei. Après vous être frayé un passage entre touristes et tableaux, mourrant presque de soif, vous irez vous offrir un verre d'eau ultrachic au Water Bar de chez Colette tout proche.

Vous préférez faire les magasins ? Quand vous aurez épuisé votre carte de crédit au Printemps, les exquis plats biologiques de son restaurant Biotifull Place sauront vraiment vous récompenser. Après une visite prolongée des luxueux objets de la Maison Baccarat, il faut absolument essayer d'obtenir une table au Cristal Room Baccarat décoré par Philippe Starck. Si vous n'y arrivez pas et que vous avez toujours envie de plonger dans un monde scintillant, vous trouverez sûrement une table dans le restaurant d'Alain Ducasse à l'hôtel Plaza Athénée. Vous y dînerez sous une voûte de lustres en cristal, vous donnant l'impression de voir tous vos rêves réalisés – ne serait-ce que pour une nuit.

La deuxième édition des *Cool Restaurants Paris* propose au lecteur un aperçu des tendances culinaires les plus actuelles de la capitale mais aussi une visite d'établissements parisiens jouissant d'une longue tradition. Ceux qui ne peuvent admirer la cuisine parisienne que de loin y trouveront des recettes provenant des nombreux restaurants présentés et pourront ainsi faire l'expérience de la gastronomie parisienne la plus raffinée dans leur propre cuisine.

Sean Weiss

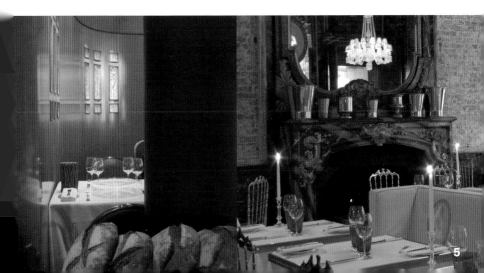

Introduction

Paris was home to the earliest restaurants. After the French Revolution, the country's finest chefs were no longer betrothed to aristocratic families. Instead they brought their culinary delights to all of Paris with small establishments serving up select dishes at individual tables. This tradition has burgeoned into Paris's thriving restaurant industry that is synonymous with innovation in haute cuisine.

Paris's most progressive restaurants cater to the cross-pollination of culture and commerce. The forerunners of this trend are the Costes Frères who have made unpretentious dining très à la mode across the city. They have Georges at the Centre Pompidou offering breathtaking vistas of Paris from high above the city. If you prefer to stay closer to the ground, check out their other venture, Café Marly at the Louvre Museum where you can linger over pastries from Lenôtre and gaze at IM Pei's glass pyramids. Positively quenched after bounding past tourists, not to mention walls of paintings, pop into nearby Water Bar Colette for an ultra chic glass of water.

Shopping more your thing? After maxing out your credit card at Printemps, head to the store's eatery Biotifull Place whose organic delicacies should provide some redemption. After perusing the bobbles at Maison Baccarat, try for a seat in the Philippe Starck decorated Cristal Room. Longing to be surrounded by shiny things, but unable to get a reservation there? Check into the hotel Plaza Athénée and you'll be guaranteed a table at Alain Ducasse's restaurant. There you'll dine beneath a crystal encrusted ceiling that's sure to make any dream come true, for at least that night.

This second edition of *Cool Restaurants Paris* provides readers insight into Paris's latest culinary trends, as well as long-standing establishments. If you are only able to admire the city's cuisine from afar, recipes from many of the featured restaurants allow you to partake in Paris's finest gastronomic experiences in your own kitchen.

Sean Weiss

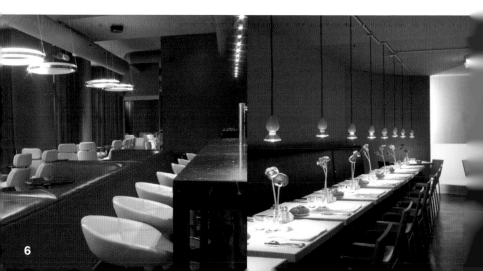

Einleitung

Paris ist die Geburtsstätte der Restaurants. Nach der Französischen Revolution waren die besten Köche des Landes nicht mehr den aristokratischen Familien verpflichtet. Stattdessen brachten Sie ganz Paris in den Genuss ihrer kulinarischen Köstlichkeiten: In kleinen Lokalen mit Einzeltischen servierten sie ausgesuchte Speisen. Aus dieser Tradition erwuchs die blühende Pariser Restaurantindustrie, die als Synonym für Innovation in der Haute Cuisine steht.

Die progressivsten Pariser Restaurants sind auf eine Synergie mit Kultur und Kommerz ausgerichtet. Vorreiter dieses Trends sind die Costes Frères, die dafür gesorgt haben, dass unprätentiöse Kulinarik in der ganzen Stadt très à la mode ist. Ihr Restaurant Georges – hoch über der Stadt im Centre Pompidou – bietet atemberaubende Ausblicke auf Paris. Wenn Sie lieber in Bodennähe bleiben, schauen Sie sich die anderen Lokale der Costes Frères an: Im Café Marly im Louvre können Sie bei Patisserie von Lenôtre verweilen und dabei den Blick auf IM Peis Glaspyramide genießen. Nachdem Sie sich dann an Touristen und Gemälden vorbeigedrängt haben und förmlich am Verdursten sind, genehmigen Sie sich ein ultraschickes Glas Wasser in der nahe gelegenen Water-Bar Colette.

Sie sind eher der Shopping-Typ? Nachdem Sie Ihre Kreditkarte im Printemps bis aufs Maximum ausgeschöpft haben, sind die Bio-Delikatessen im dortigen Restaurant Biotifull Place eine echte Entschädigung. Und nach ausgiebiger Besichtigung der edlen Stücke im Maison Baccarat, lohnt sich der Versuch, in dem von Philippe Starck kreierten Cristal Room einen Tisch zu ergattern. Wenn das fehlschlägt, Sie sich aber noch immer danach sehen, in eine Glitzerwelt einzutauchen, finden Sie mit Sicherheit einen Tisch in Alain Ducasses Restaurant im Hotel Plaza Athénée. Dort können Sie unter einem Himmel aus Kristall-Lüstern speisen, der jeden Traum wahr werden lässt – und sei es nur für diese eine Nacht.

Die zweite Auflage von *Cool Restaurants Paris* bietet dem Leser ebenso Einblicke in die aktuellsten kulinarischen Trends der französischen Hauptstadt, wie in Pariser Lokale mit langer Tradition. Wer die Pariser Küche nur aus der Ferne bewundern kann, findet Rezepte aus zahlreichen der vorgestellten Restaurants, die ihm die Möglichkeit bieten, feinste Pariser Gastronomie in der eigenen Küche zu erleben.

Sean Weiss

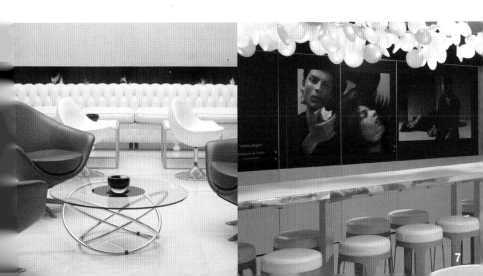

Introducción

París es la ciudad natal de los restaurantes. Al finalizar la Revolución Francesa los mejores cocineros del país ya no estaban obligados a trabajar para las familias aristocráticas. En lugar de eso acercaron a todo París el placer de sus delicias gastronómicas: En pequeños locales con mesas individuales servían platos escogidos. A partir de esta tradición surgió una floreciente industria parisina de restaurantes sinónimo de innovación en la haute cuisine.

Los restaurantes parisinos más progresistas están orientados hacia una sinergia de la cultura y el comercio. Los precursores de esta tendencia han sido los Costes Frères, que han convertido una gastronomía poco pretenciosa en algo très à la mode en toda la ciudad. Su restaurante Georges, situado muy por encima de la ciudad en el Centre Pompidou, ofrece vistas espectaculares de París. Pero si prefiere mantener los pies más cerca del suelo no dude en visitar otros locales de los Costes Frères, como el Café Marly en el Louvre, donde puede deleitarse con la patisserie de Lenôtre mientras disfruta de las vistas de la pirámide de cristal IM Peis. Y si después de mezclarse con los turistas para contemplar las pinturas tiene sed, dése el placer de tomarse un elegante vaso de agua en el cercano Water Bar Colette.

¿Le gusta más ir de tiendas? Si es así, después de haber agotado su tarjeta de crédito en Printemps el restaurante de exquisiteces biológicas Biotifull Place es un verdadero resarcimiento. Y después de contemplar largamente las exquisitas piezas de Maison Baccarat, merece la pena intentar conseguir una mesa en el Cristal Room, creación de Philippe Starck. Si están todas ocupadas pero aún así desea sumergirse en un mundo centelleante, con toda seguridad encontrará mesa en el Alain Ducasses Restaurant, en el hotel Plaza Athénée. Aquí puede disfrutar de su cena bajo un cielo de prismas de cristal que convertirá en realidad sus sueños, aunque sólo sea por esa noche.

La segunda edición de *Cool Restaurants Paris* presenta al lector tanto las tendencias gastronómicas más actuales de la capital francesa como los locales parisinos de larga tradición. Para quien sólo le sea posible disfrutar de la cocina parisina desde la distancia, en esta obra encontrará recetas de muchos de los restaurantes que aquí presentamos para poder deleitarse de la más exquisita gastronomía parisina en su propia cocina.

Sean Weiss

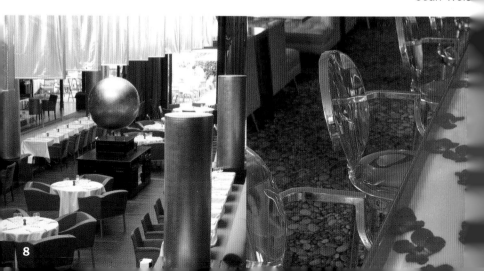

Introduzione

Parigi è la culla dei ristoranti. In seguito alla Rivoluzione Francese, i migliori cuochi della nazione non furono più obbligati al servizio esclusivo delle famiglie aristocratiche. Cominciarono, invece, con l'iniziare l'intera Parigi al piacere delle loro delizie culinarie, servendo piatti ricercati in piccoli locali con tavoli ad un solo posto. Da questa tradizione derivò la fiorente industria della ristorazione parigina, il sinonimo di innovazione nella haute cuisine.

I ristoranti parigini più progressivi sono orientati verso una sinergia tra cultura e commercio. I precorritori di questa tendenza sono i frères Costes, a cui va il merito di aver reso una modesta arte della cucina très à la mode in tutta Parigi. Il loro ristorante Georges, che dal Centre Pompidou s'innalza sulla città, offre vedute panoramiche mozzafiato su Parigi. Se preferite rimanere un pochino più in basso, date uno sguardo agli altri locali dei frères Costes: al Café Marly, al Louvre, potete soffermarvi alla pasticceria di Lenôtre per godervi, tra le altre cose, la vista della piramide di vetro di IM Pei. Quando vi sarete poi fatti largo tra turisti e dipinti e vi sembrerà davvero di morire di sete, concedetevi un raffinatissimo bicchiere d'acqua al vicino Water Bar Colette.

Siete invece più dei tipi da shopping? Dopo aver esaurito la vostra carta di credito al Printemps, potrete rifarvi con le prelibatezze biologiche del ristorante Biotifull Place situato all'interno dei grandi magazzini. E dopo una lunga visita ai pregiati pezzi della Maison Baccarat, vale la pena cercare di accaparrarsi un tavolo al Cristal Room, ideato da Philippe Starck. Se il tentativo fallisce e avete ancora voglia di immergervi in un mondo scintillante, troverete sicuramente un tavolo al ristorante di Alain Ducasse all'hotel Plaza Athénée, dove potrete mangiare sotto un cielo di lampadari di cristallo. E ogni sogno diventerà realtà, sia anche solo per una notte.

La seconda edizione di *Cool Restaurants Paris* offre al lettore uno sguardo da vicino sia alle nuovissime tendenze culinarie della capitale francese sia ai locali parigini con una lunga tradizione. E per chi potrà apprezzare la cucina parigina solo da lontano, il libro contiene ricette di molti dei ristoranti presentati, con cui sperimentare nella propria cucina la raffinatissima gastronomia parigina.

Sean Weiss

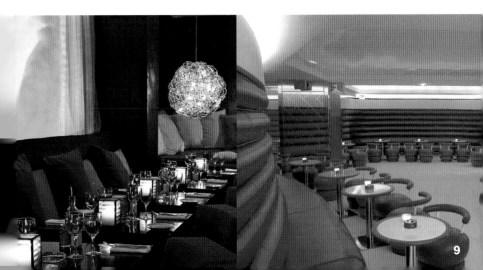

6 New York

Design & Chef: Gangneux Jérôme | Owners: Gangneux Jérôme, Jean Pierre Vigato

6, Avenue de New-York | 75016 Paris | 16e arrondissement
Phone: +33 1 40 70 03 30
Metro: Alma-Marceau, Iéna
Opening hours: Mon–Fri 12:15 pm to 2:15 pm, 7:30 pm to 10:30 pm,
Sat 7:30 pm to 11 pm
Average price: € 60
Cuisine: French

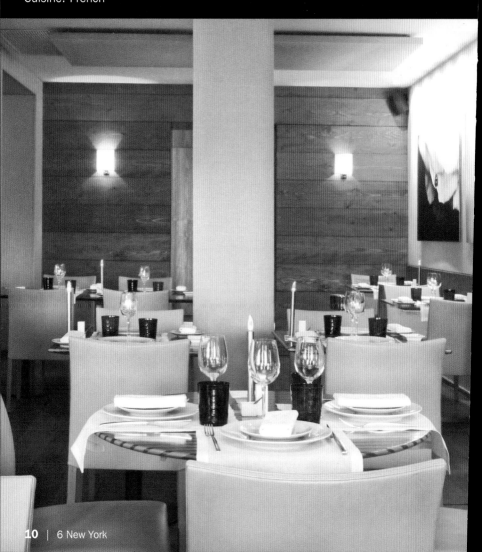

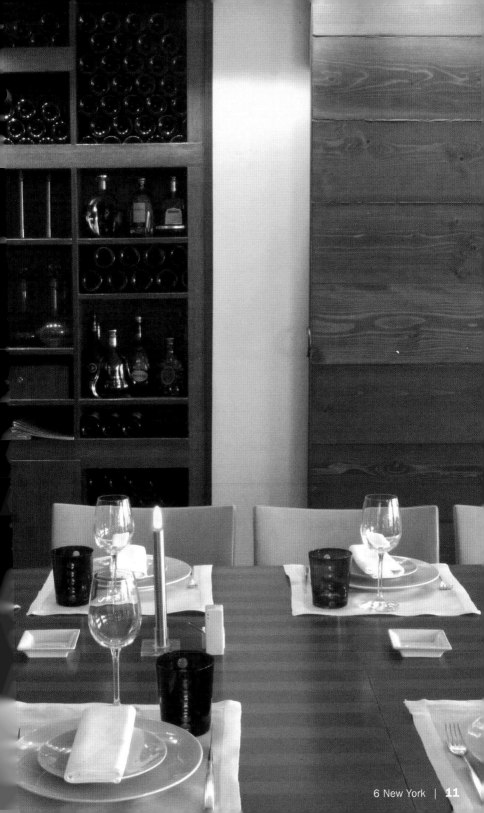

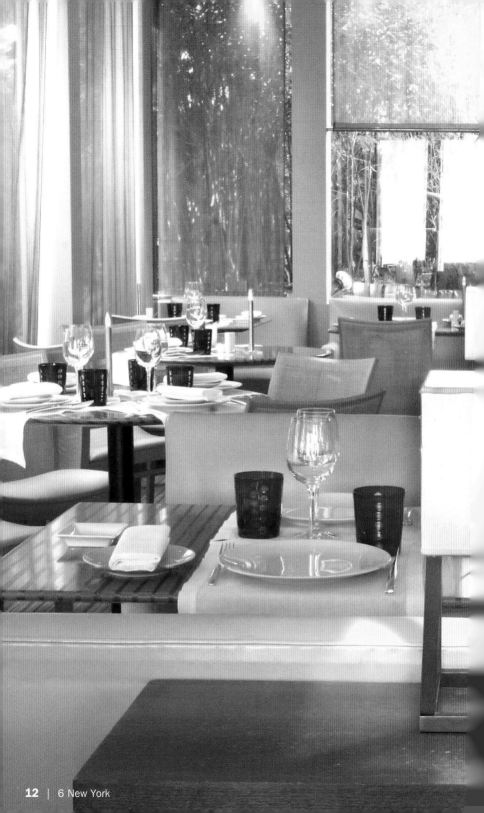

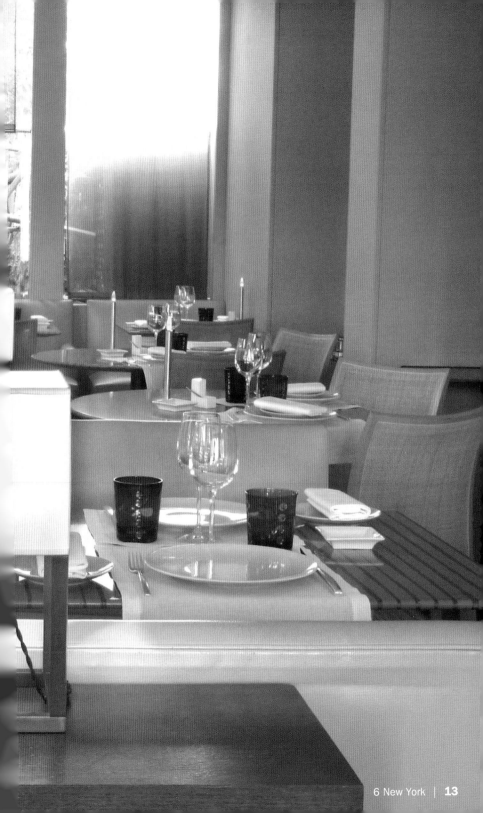

Alain Ducasse
au Plaza Athénée

Design: Patrick Jouin | Chef: Alain Ducasse & Christophe Moret

25, Avenue Montaigne | 75008 Paris | 8e arrondissement
Phone: +33 1 53 67 65 00
www.plaza-athenee-paris.com | adpa@alain-ducasse.com
Metro: Alma-Marceau, Franklin D. Roosevelt
Opening hours: Mon–Fri 7:45 pm to 10:15 pm, Thu–Fri 12:45 pm to 2:15 pm
Average price: € 200
Cuisine: Contemporary French

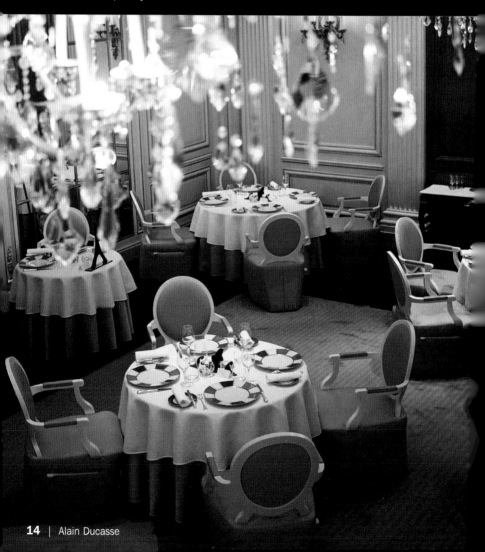

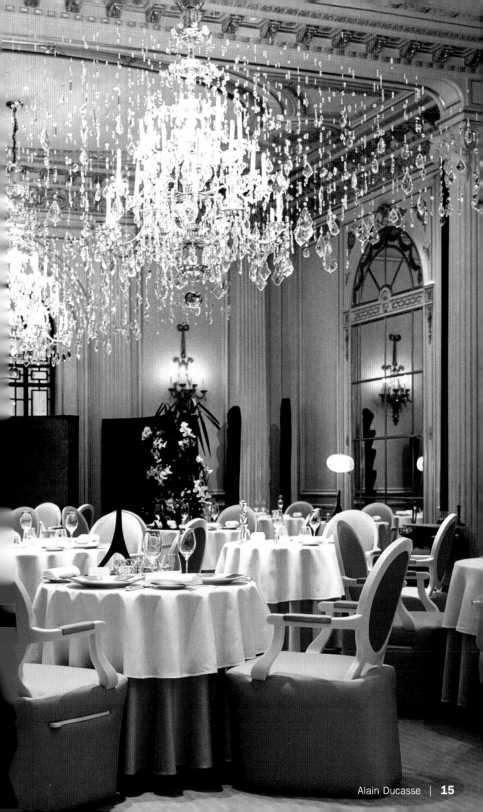

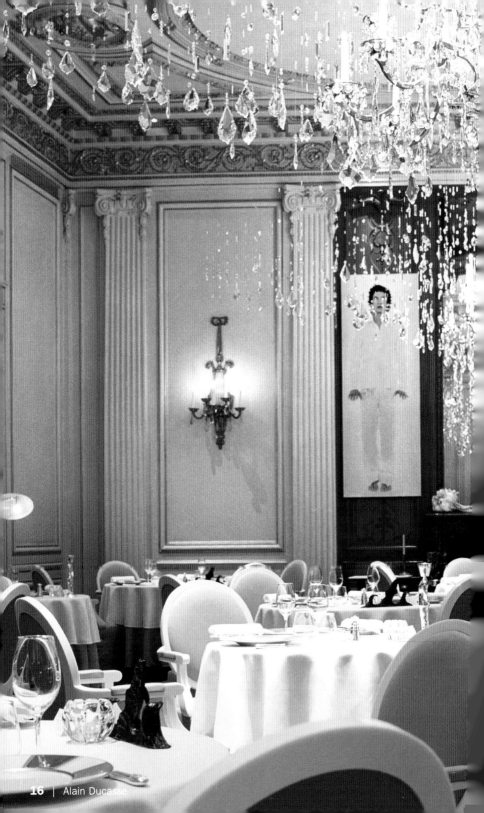

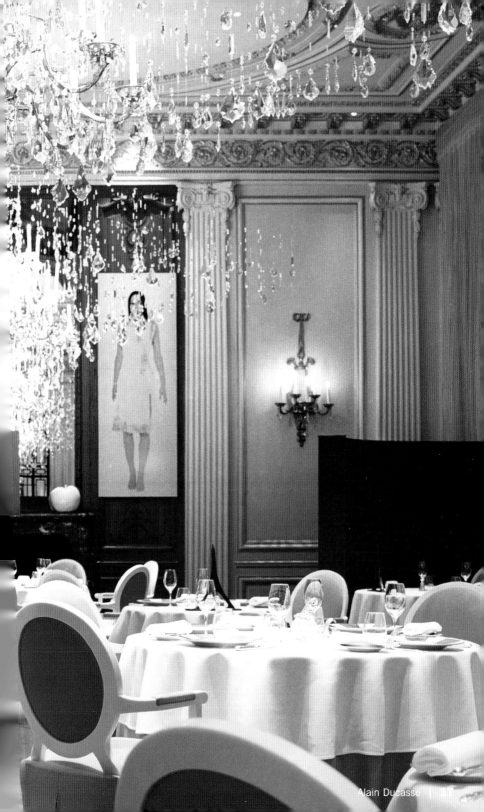

Alain Ducasse | 17

Arpège

Chef & Owner: Alain Passard

84, Rue de Varenne | 75007 Paris | 7e arrondissement
Phone: +33 1 47 05 09 06
www.alain-passard.com | arpege@alain-passard.com
Metro: Varenne
Opening hours: Mon–Fri 12:30 pm to 2:30 pm, 8 pm to 10:30 pm
Average price: € 90
Cuisine: French

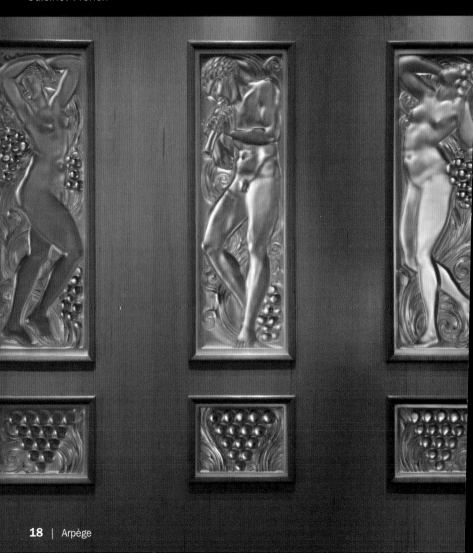

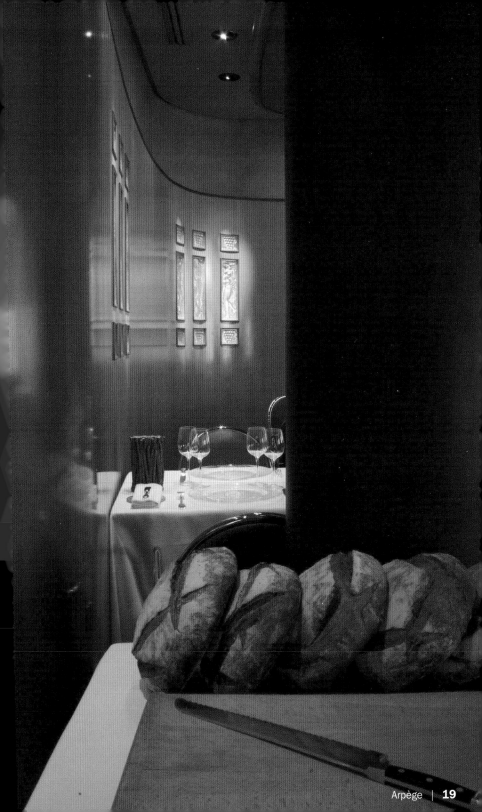

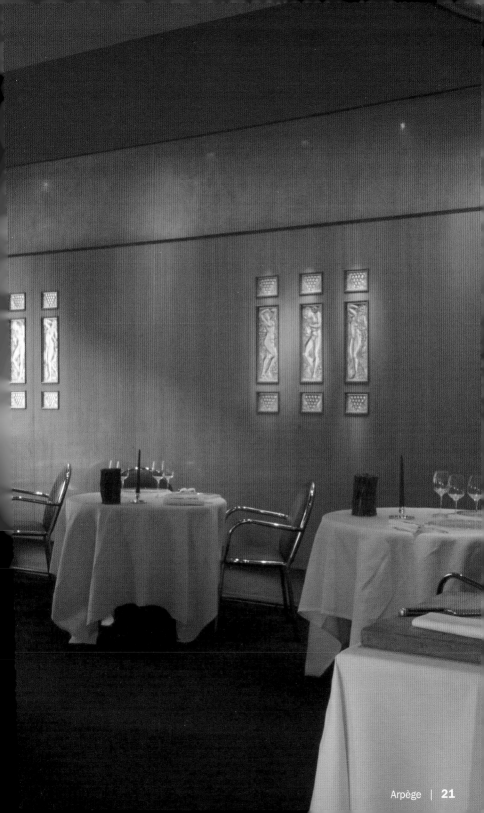

Bertie

Design: Christophe Pillet | Chef: Guillaume Hardy
Owner: Alexandre Breval

6, Rue Edouard VII | 75009 Paris | 9e arrondissement
Phone: +33 1 53 05 50 55
Metro: Opéra
Opening hours: Mon–Sat 8:30 am to 2 am, Sun 10 am to 2 am
Average price: € 40
Cuisine: World food
Special features: Terrace, lounge and cocktails

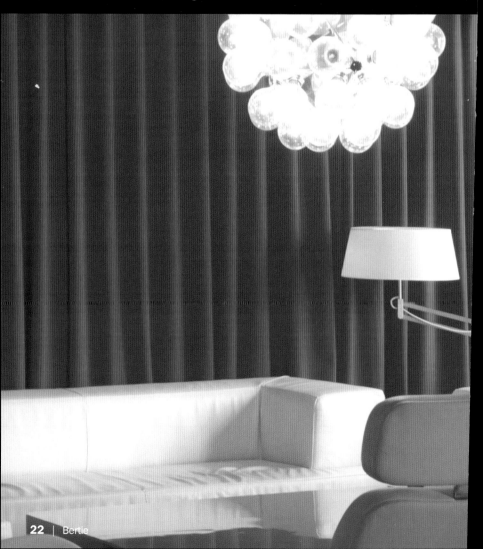

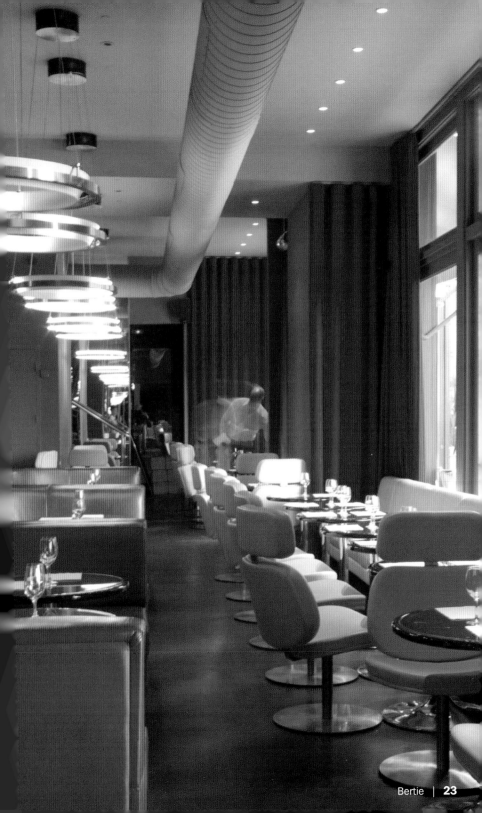

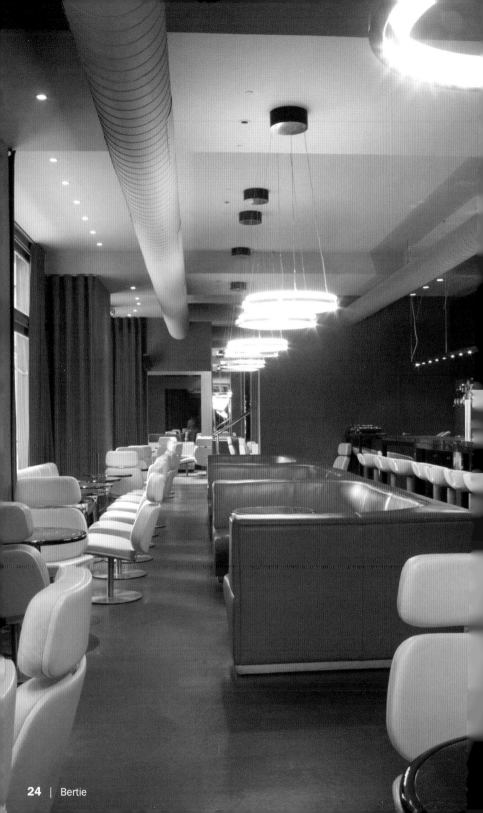

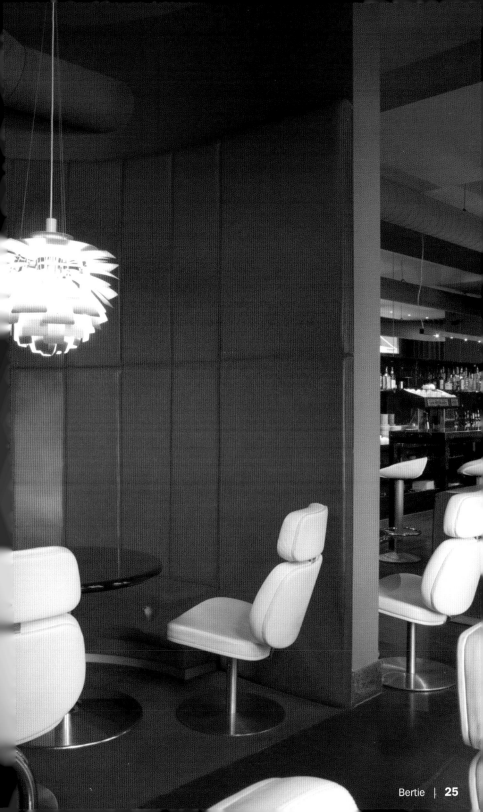

Légumes variés

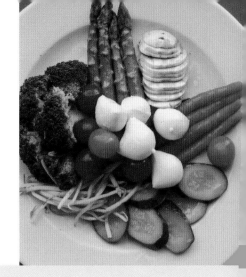

Varicolored Vegetables

Buntes Gemüse

Verdura variada

Verdura varietà

1 brocoli
16 tiges d'asperge, seulement les 10 cm de la pointe
16 carottes primeurs épluchées
2 petites courgettes en rondelles
4 champignons en tranches
8 c. à soupe de pousses
8 tomates Sol Gold (tomates jaunes orangées)
20 tomates cerises
20 petites boules de mozzarella

4 c. à soupe de vinaigre de vin blanc
Sel, poivre, sucre
1 c. à café de moutarde
4 c. à soupe d'huile d'olive

Faire cuire al dente le brocoli, les asperges, les carottes et les courgettes dans de l'eau salée, dresser sur des assiettes et décorer avec le reste des légumes, les champignons et les petites boules de mozzarella. Préparer une sauce avec le vinaigre de vin blanc, le sel, le poivre, le sucre, la moutarde et l'huile d'olive et en napper les légumes.

1 broccoli
16 green asparagus, only the upper 4 inches
16 baby carrots, peeled
2 small zucchini, in slices
4 button mushrooms, in slices
8 tbsp sprouts
8 Sol-Gold tomatoes (yellow-orange tomatoes)
20 cherry tomatoes
20 mozzarella balls

4 tbsp white wine vinegar
Salt, pepper, sugar
1 tsp mustard
4 tbsp olive oil

Boil broccoli, asparagus, carrots and zucchini in salted water until tender, and arrange with the let vegetables, mushrooms and mozzarella balls dec oratively on plates and set aside. Make a dressing out of vinegar, salt, pepper, sugar, mustard and olive oil and drizzle over the vegetables.

1 Brokkoli
16 Stangen grüner Spargel, nur die oberen 10 cm
16 Baby-Karotten, geschält
2 kleine Zucchini, in Scheiben
4 Champignons, in Scheiben
8 EL Sprossen
8 Sol Gold-Tomaten (gelb-orangene Tomaten)
20 Kirschtomaten
20 Mozzarellabällchen

4 EL Weißweinessig
Salz, Pfeffer, Zucker
1 TL Senf
4 EL Olivenöl

Brokkoli, Spargel, Karotten und Zucchini in Salzwasser bissfest garen, mit dem restlichen Gemüse, den Pilzen und den Mozzarellabällchen dekorativ auf Tellern anrichten und beiseite stellen. Aus Weißweinessig, Salz, Pfeffer, Zucker, Senf und Olivenöl ein Dressing zubereiten und über das Gemüse träufeln.

1 brécol
16 tallos de espárragos verdes, sólo los 10 cm superiores
16 zanahorias baby, peladas
2 calabacines pequeños, en rodajas
4 champiñones, en rodajas
8 cucharadas de brotes
8 tomates Sol Gold (tomates amarillo anaranjados)
20 tomates cereza
20 bolitas de mozzarella

4 cucharadas de vinagre de vino blanco
Sal, pimienta, azúcar
1 cucharadita de mostaza
4 cucharadas de aceite de oliva

Cueza el brécol, los espárragos, las zanahorias y los calabacines en agua con sal hirviendo hasta que estén crujientes. Reparta los ingredientes en los platos y decore con el resto de la verdura, los champiñones y las bolitas de mozzarella. Prepare el aliño con el vinagre de vino blanco, la sal, la pimienta, el azúcar, la mostaza y el aceite de oliva y viértalo por encima de la verdura.

1 broccolo
16 asparagi verdi interi (solo i primi 10 cm di punta)
16 carote baby mondate
2 zucchine piccole a rondelle
4 champignon a fette
8 cucchiai di germogli
8 pomodori Sol Gold (pomodori giallo-arancio)
20 pomodorini ciliegia
20 bocconcini di mozzarella

4 cucchiai di aceto di vino bianco
Sale, pepe, zucchero
1 cucchiaino di senape
4 cucchiai di olio d'oliva

In acqua salata lessate al dente il broccolo, gli asparagi, le carote e le zucchine, con la verdura restante, con i funghi e i bocconcini di mozzarella create sui piatti una composizione decorativa e metteteli da parte. Con l'aceto, il sale, il pepe, lo zucchero, la senape e l'olio d'oliva preparate un condimento per l'insalata e versatelo a gocce sulla verdura.

Biotifull Place

Design: Resodesign, Philippe Di Méo | Owner: Philippe Di Méo

66–68, Boulevard Haussmann | 75009 Paris | 9e arrondissement
Phone: +33 1 42 82 77 44
Metro: Havre Caumartin
Opening hours: Mon–Sat 9:30 am to 7 pm
Average price: € 20
Cuisine: Organic food, vegetarian, fish and poultry

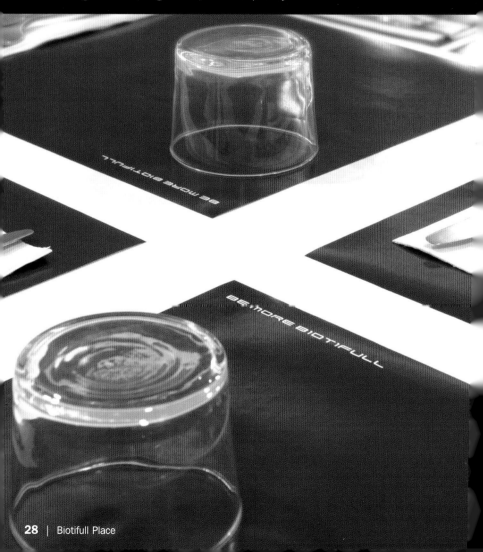

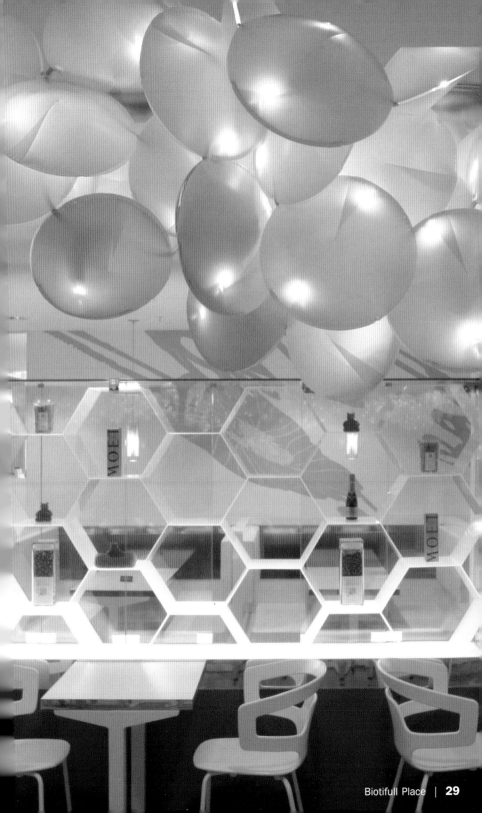

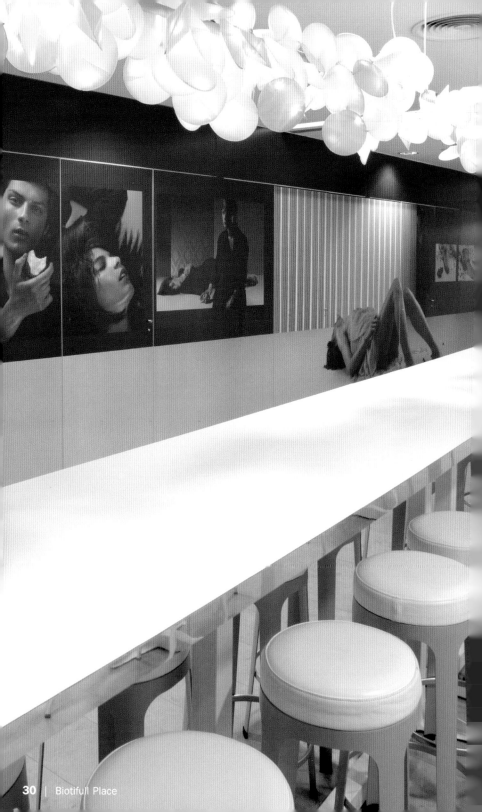

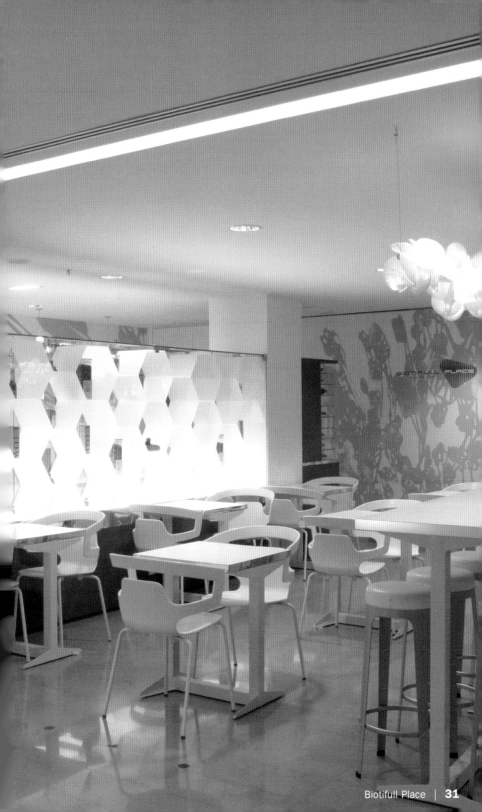

Brasserie Lipp

Chef: Monsieur Muller | Owner: Olivier Bertrand

151, Boulevard Saint-Germain | 75006 Paris | 6e arrondissement
Phone: +33 1 45 48 53 91
www.brasserie-lipp.fr
Metro: Saint-Germain-des-Prés
Opening hours: Mon–Sun noon to 1 am
Average price: € 50
Cuisine: French, Alsatian

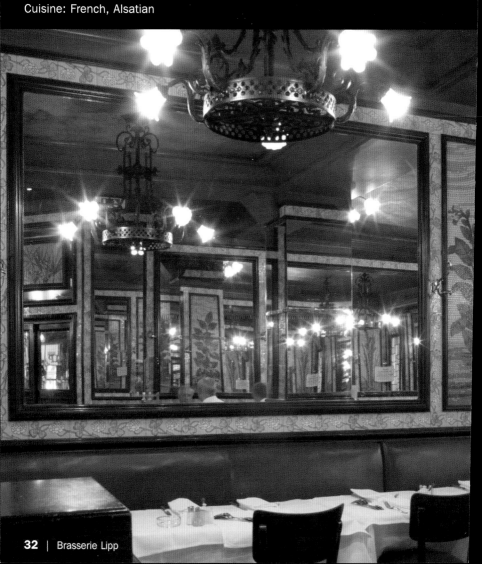

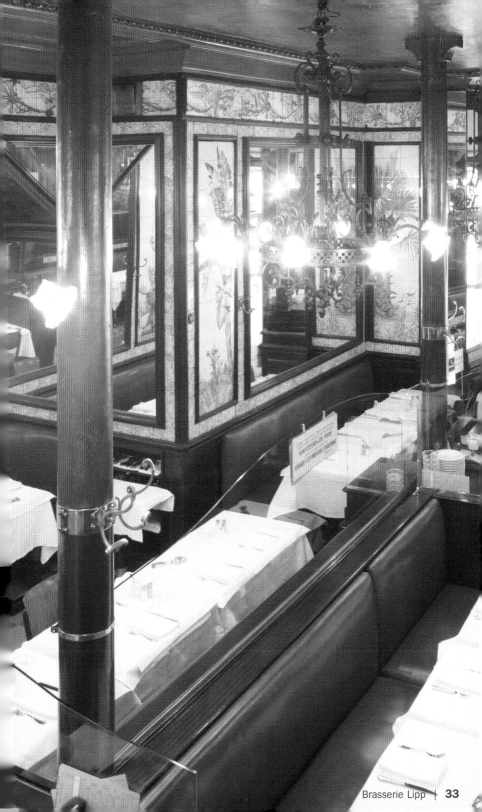

Choucroute
spéciale au jarret de porc

Sauerkraut Special with Pork Knuckles
Sauerkraut Spezial mit Schweinshaxe
Col agria especial con codillo
Crauti speciali con stinco di maiale

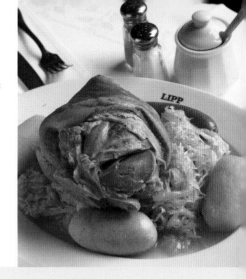

4 jarrets de porc de 600 g
1 oignon émincé
60 g de saindoux de porc
1 kg de choucroute crue
1 c. à café de baies de genièvre
1 c. à café de grains de poivre
1 c. à café de sel
120 ml de vin blanc
240 ml d'eau
4 saucisses au cumin
4 saucisses de Francfort
8 grosses pommes de terre à l'anglaise

Faire cuire les jarrets pendant 90 minutes dans de l'eau salée. Faire fondre l'oignon dans le saindoux, mettre la choucroute et ajouter les épices, le vin blanc et l'eau. Couvrir et laisser cuire à feu doux pendant 45 minutes. Faire chauffer les saucisses sur la choucroute. Servir avec des pommes de terre à l'anglaise.

4 pork knuckles, 20 oz each
1 onion, in thin stripes
2 oz pork lard
2 pounds fresh sauerkraut
1 tsp juniper berries
1 tsp pepper corns
1 tsp salt
120 ml white wine
240 ml water
4 caraway sausages
4 franks
8 large boiled potatoes

Boil the pork knuckles in salted water for 90 minutes. Sauté the onion in the pork lard, add the sauerkraut and stir in the spices, white wine and water. Let simmer with a closed lid on low heat for 45 minutes. Heat the sausages on the sauerkraut. Serve with boiled potatoes.

4 Schweinshaxen à 600 g
1 Zwiebel, in feinen Streifen
60 g Schweineschmalz
1 kg rohes Sauerkraut
1 TL Wacholderbeeren
1 TL Pfefferkörner
1 TL Salz
120 ml Weißwein
240 ml Wasser
4 Kümmelwürstchen
4 Frankfurter Würstchen
8 große Salzkartoffeln

Die Schweinshaxen 90 Minuten in Salzwasser kochen. Die Zwiebel in dem Schweineschmalz andünsten, das Sauerkraut zugeben und die Gewürze, Weißwein und Wasser unterrühren. Bei geschlossenem Deckel auf schwacher Flamme 45 Minuten kochen lassen. Die Würstchen auf dem Sauerkraut erwärmen. Mit Salzkartoffeln servieren.

4 codillos de cerdo de 600 g cada uno
1 cebolla, en juliana
60 g de manteca de cerdo
1 kg de col agria cruda
1 cucharadita de bayas de enebro
1 cucharadita de granos de pimienta
1 cucharadita de sal
120 ml de vino blanco
240 ml de agua
4 salchichas con comino
4 salchichas Frankfurt
8 patatas grandes cocidas

Cueza el codillo en agua hirviendo con sal durante 90 minutos. Rehogue la cebolla en la manteca de cerdo, añada la col y las especias, el vino blanco y agua y remueva. Con la cazuela tapada deje que hierva a fuego lento durante 45 minutos. Caliente las salchichas en la col. Sirva con las patatas.

4 stinchi di maiale da 600 g l'uno
1 cipolla a listarelle sottili
60 g di strutto
1 kg di crauti crudi
1 cucchiaino di bacche di ginepro
1 cucchiaino di pepe in grani
1 cucchiaino di sale
120 ml di vino bianco
240 ml di acqua
4 würstel al cumino
4 würstel di Francoforte
8 patate grosse lessate in acqua salata

Lessate gli stinchi di maiale in acqua salata per 90 minuti. Fate appassire la cipolla nello strutto, aggiungete i crauti e incorporatevi le spezie, il vino bianco e l'acqua. Coprite e lasciate cuocere a fuoco lento per 45 minuti. Fate riscaldare i würstel sui crauti. Servite con le patate lesse.

Café de Flore

Design: 1887 | Owners: Monsieur + Madame Siljegovic

172, Boulevard Saint-Germain | 75006 Paris | 6e arrondissement
Phone: +33 1 45 48 55 26
www.cafe-de-flore.com | info@cafe-de-flore.com
Metro: Saint-Germain-des-Prés
Opening hours: Mon–Sun 7 am to 1:30 am
Average price: € 20
Cuisine: Café, traditional French
Special features: Traditional café from 1887

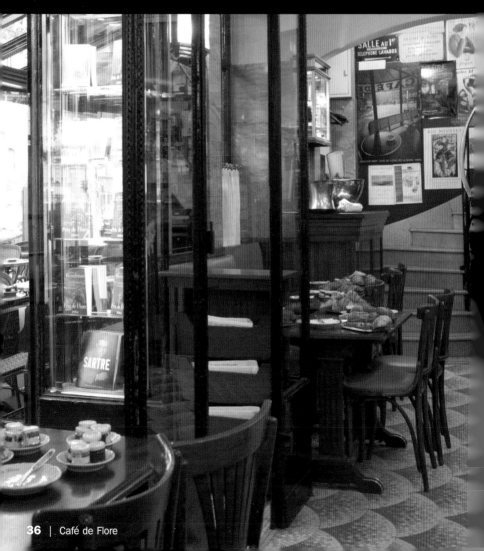

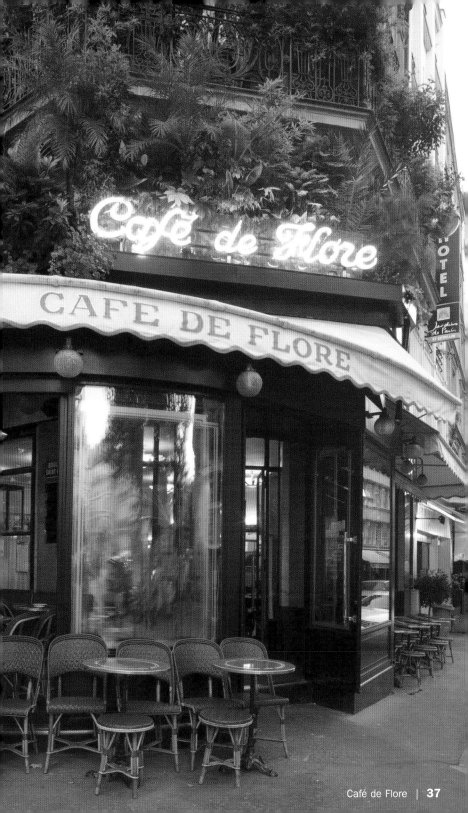

Café de l'Homme

Design: Pascale de Montremy | Chef: Veronique Melloul
Owner: Raphaël de Montremy

17, Place du Trocadero | 75016 Paris | 16e arrondissement
Phone: +33 1 44 05 30 15
www.lecafedelhomme.com | reservations@lecafedelhomme.com
Metro: Trocadero
Opening hours: Mon–Sun noon to 2 am
Average price: € 45
Cuisine: Traditional
Special features: Beautiful view of the Eiffel Tower

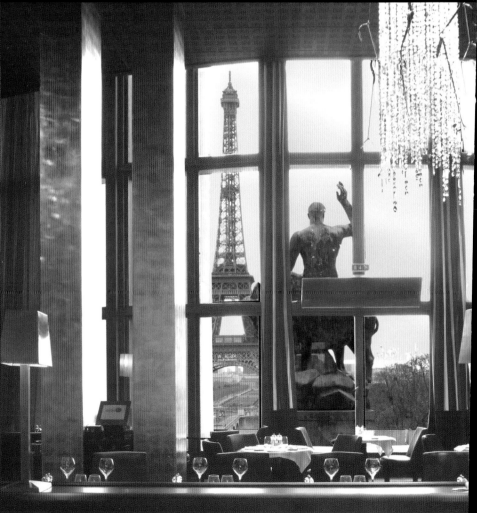

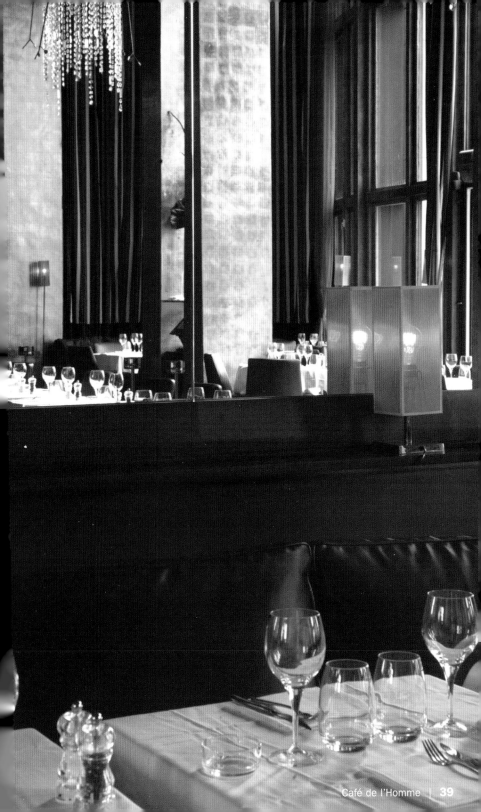

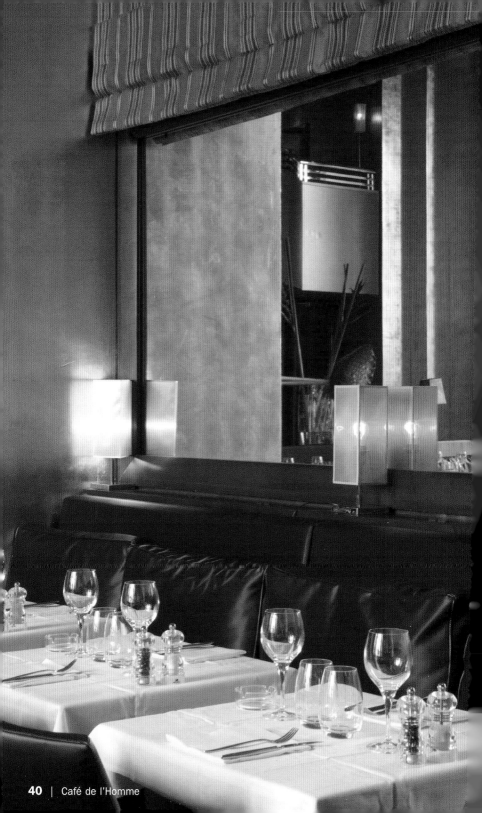

L'HOMME · ΑΝΔΡΟΣ · 大 · אדם

Salade césar traditionelle

Traditional Cesar's Salad

Traditioneller Cäsar-Salat

Ensalada césar tradicional

Caesar Salad tradizionale

4 petites salades romaines
1 laitue d'hiver
4 blancs de poulet
2 c. à soupe d'huile d'olive
Sel, poivre

Sauce :
3 anchois
1 gousse d'ail pelée
2 c. à soupe de parmesan râpé
4 c. à soupe de vinaigre de Sherry
Poivre
2 c. à soupe de l'huile des anchois
2 c. à soupe d'huile d'olive

Couper les romaines en quartiers, laver et esso-rer. Couper la laitue d'hiver en lamelles, réserver. Saler et poivrer les blancs de poulet et les faire revenir dans de l'huile d'olive pendant 4 minutes de chaque côté. Les couper en bouchées et les mettre au chaud. Mettre les ingrédients de la sauce dans un mixeur et mixer pour obtenir une sauce homogène. Rectifier l'assaisonnement si nécessaire. Répartir la laitue dans quatre assiet-tes creuses, déposer un quart de romaine et un blanc de poulet dans chaque assiette et nappe de sauce.

4 baby roman lettuce heads
1 iceberg lettuce
4 chicken breasts
2 tbsp olive oil
Salt, pepper

Dressing:
3 anchovies
1 clove of garlic, peeled
2 tbsp parmesan, grated
4 tbsp sherry vinegar
Pepper
2 tbsp anchovy oil
2 tbsp olive oil

Quarter, wash and dry the roman lettuce heads Cut the iceberg lettuce in stripes, set aside Season the chicken breasts with salt and peppe and sear in olive oil on each side for 4 minutes cut in bite-sized pieces and keep warm. Combir the ingredients for the dressing in a blender an mix until smooth. Season if necessary. Divide th iceberg lettuce onto four deep plates, arrang one quartered roman lettuce and one chicke breast on top and drizzle with the dressing.

Baby-Römersalate
Eisbergsalat
Hähnchenbrüste
EL Olivenöl
alz, Pfeffer

)ressing:
Sardellen
Knoblauchzehe, geschält
EL Parmesan, gerieben
EL Sherryessig
feffer
EL Sardellenöl
EL Olivenöl

Die Römersalate vierteln, waschen und trocken schleudern. Den Eisbergsalat in Streifen schneiden, beiseite stellen. Die Hähnchenbrüste mit Salz und Pfeffer würzen und in Olivenöl von jeder Seite 4 Minuten braten, in mundgerechte Stücke schneiden und warm stellen. Die Zutaten für das Dressing in einen Mixer geben und glatt mixen. Evtl. nachwürzen. Den Eisbergsalat in vier tiefen Tellern verteilen, jeweils einen geviertelten Römersalat und eine Hähnchenbrust darauf anrichten und mit dem Dressing beträufeln.

lechugas romanas baby
lechuga Iceberg
pechugas de pollo
cucharadas de aceite de oliva
al, pimienta

liño:
boquerones
diente de ajo, pelado
cucharadas de queso parmesano, rallado
cucharadas de vinagre de jerez
imienta
cucharadas de aceite de boquerones
cucharadas de aceite de oliva

Corte en cuartos las lechugas romana, lávelas y séquelas en la centrifugadora. Corte la lechuga Iceberg en tiras y reserve. Salpimiente las pechugas de pollo y fríalas en aceite de oliva durante 4 minutos por cada lado, córtelas en porciones pequeñas y resérvelas calientes. Ponga los ingredientes para el aliño en la batidora y mézclelos. Si es necesario condimente más. Reparta la lechuga Iceberg en cuatro platos hondos, añada un cuarto de la lechuga romana y disponga encima los trozos de pechuga. Aderece con el aliño.

cespi di lattuga romana baby
lattuga iceberg
petti di pollo
cucchiai di olio d'oliva
ale, pepe

ondimento per l'insalata:
acciughe
spicchio d'aglio sbucciato
cucchiai di parmigiano grattugiato
cucchiai di aceto di sherry
epe
cucchiai di olio di acciughe
cucchiai di olio d'oliva

Tagliate in quattro i cespi di lattuga romana, lavateli e asciugateli nella centrifuga per insalata. Tagliate la lattuga iceberg a listarelle e mettetela da parte. Salate e pepate i filetti di pollo e passateli nell'olio d'oliva per 4 minuti per lato, tagliateli a bocconcini e metteteli in caldo. Mettete in un frullatore gli ingredienti per il condimento per l'insalata e frullateli bene. Se necessario, condite ancora. Distribuite la lattuga iceberg su quattro piatti fondi, sistematevi sopra un cespo di lattuga romana tagliato in quattro e un petto di pollo, e versatevi alcune gocce del condimento per l'insalata.

Café Marly

Design: Olivier Gargniere | Chef: William Grivet

Cour Napoléon 93, Rue de Rivoli | 75001 Paris | 1ère arrondissement
Phone: +33 1 49 26 06 60
s.a.marly@wanadoo.fr
Metro: Palais Royal, Musée du Louvre
Opening hours: Mon–Sun 8 am to 2 am
Average price: € 25
Cuisine: French

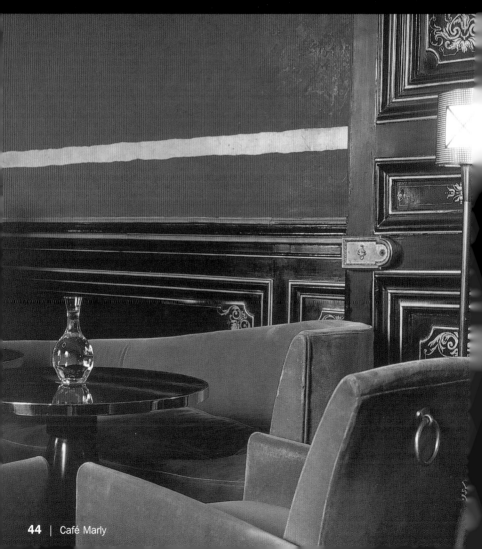

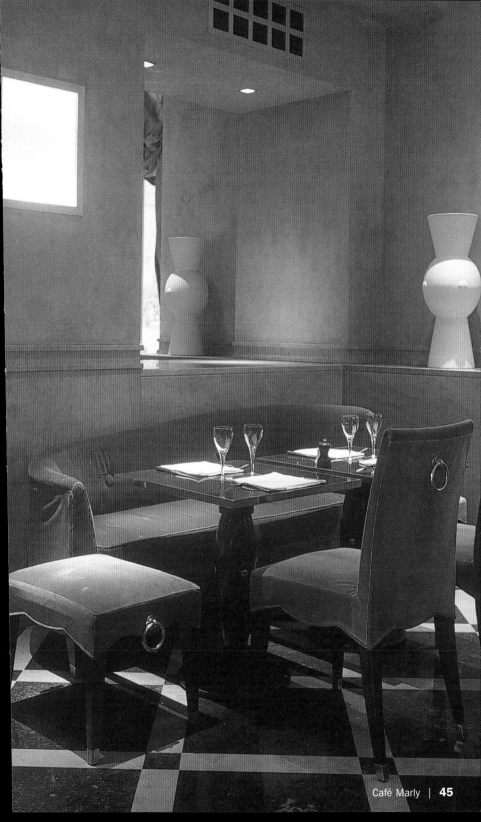

Chez Paul

Chef: Teyant Eric | Owner: Daniel Karrenbauer

13, Rue de Charonne | 75011 Paris | 11e arrondissement
Phone: +33 1 47 00 34 57
Metro: Bastille
Opening hours: Mon–Sun noon to 2:30 pm, 7:15 pm to 12:30 am
Average price: € 20
Cuisine: Traditionelle et fraîcheur French
Special features: Typique bistrot

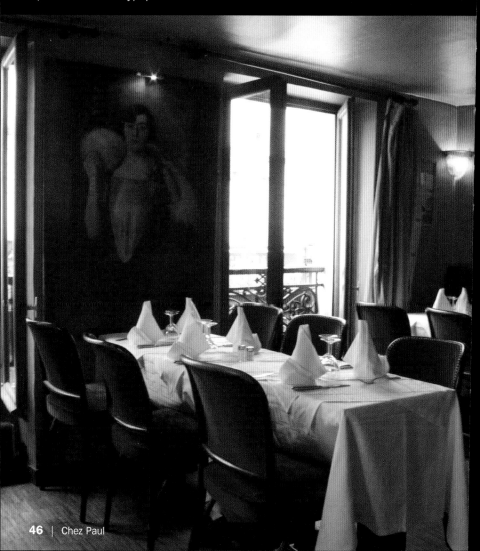

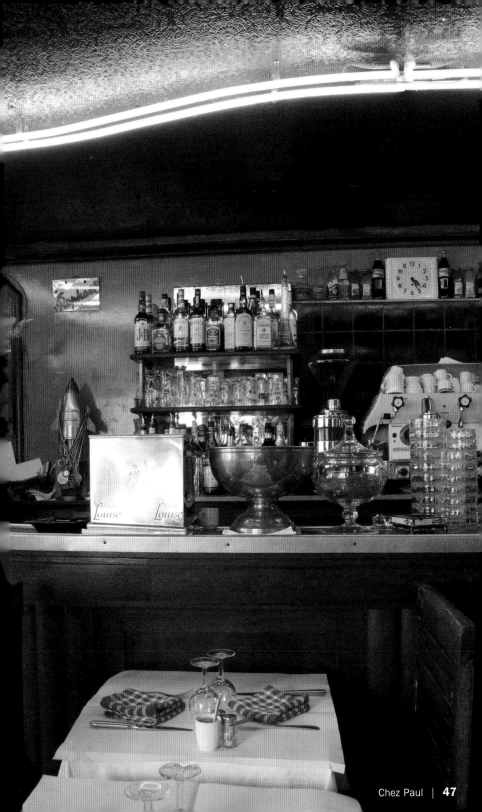

Cuisse de lièvre
au chèvre et à la menthe poivrée

Hare Leg with Goat Cheese and Peppermint

Hasenkeule mit Ziegenkäse und Pfefferminze

Muslos de liebre con queso de cabra y menta

Cosce di lepre con formaggio di capra e menta piperita

4 cuisses de lièvre d'élevage
1 rouleau de fromage de chèvre d'env. 200 g
1 botte de menthe fraîche hachée
1 échalote hachée
500 ml de crème
100 ml de vin blanc
2 c. à soupe d'huile d'olive
Sel, poivre
Cresson de source et feuilles de menthe pour la décoration

Mélanger la menthe avec le fromage de chèvre, saler, poivrer et mettre au frais. Désosser les cuisses de lièvre, assaisonner, badigeonner d'huile d'olive et enrouler en papillotes dans des feuilles d'aluminium. Chauffer un grand faitout d'eau salée et y faire cuire les cuisses pendant 90 minutes. Réserver 4 c. à soupe de chèvre à la menthe. Réchauffer et faire réduire le reste du chèvre avec l'échalote hachée, la crème et le vin blanc. Pour servir, sortir les cuisses des papillotes, dresser les assiettes, déposer des quenelles d'une c. à soupe de chèvre à la menthe et napper de sauce. Garnir de cresson de source et de feuilles de menthe. Accompagner de boulettes en serviette.

4 hare legs
1 roll goat cheese, approx. 6 ½ oz
1 bunch peppermint, chopped
1 shallot, diced
500 ml cream
100 ml white wine
2 tbsp olive oil
Salt, pepper
Watercress and mint leaves for decoration

Mix the mint leaves with the goat cheese, sea son with salt and pepper and chill. Debone the hare legs, season, rub with olive oil and wrap in aluminum foil. Bring a large pot with salted wate to a boil and boil the hare legs for 90 minutes Reserve 4 tbsp of the goat cheese mixture, brin the rest with diced shallots, cream and white win to a boil. To serve, shape 1 tbsp of goat chees mixture for each plate into a scoop, remove the hare legs from the aluminum foil and lean agains the goat cheese and drizzle sauce over it. Garnis with watercress and mint leaves. Serve with nap kin dumplings.

4 Keulen von Stallhasen
1 Rolle Ziegenkäse, ca. 200 g
1 Bund Minze, gehackt
1 Schalotte, gehackt
500 ml Sahne
100 ml Weißwein
2 EL Olivenöl
Salz, Pfeffer
Brunnenkresse und Minzeblätter zur Dekoration

Die Minze mit dem Ziegenkäse mischen, mit Salz und Pfeffer würzen und kaltstellen. Die Hasenkeule ausbeinen, würzen, mit Olivenöl einreiben und in Alufolie wickeln. Einen großen Topf mit Salzwasser erhitzen und die Hasenkeulen 90 Minuten kochen. 4 EL der Ziegenkäsemischung zurückbehalten, den Rest mit Schalottenwürfeln, Sahne und Weißwein aufkochen. Zum Servieren jeweils 1 EL der Ziegenkäsemischung zu einer Nocke abstechen, die Hasenkeule aus der Alufolie nehmen und anlegen und alles mit der Sauce beträufeln. Mit Brunnenkresse und einigen Minzeblättern garnieren. Dazu passen Serviettenknödel.

4 muslos de liebre de criadero
1 rollo de queso de cabra, aprox. 200 g
1 manojo de menta, picada
1 chalote, picado
500 ml de nata
100 ml de vino blanco
2 cucharadas de aceite de oliva
Sal, pimienta
Berros y hojas de menta para decorar

Mezcle la menta con el queso de cabra, salpimiente y reserve frío. Deshuese los muslos, sazónelos, frótelos con aceite de oliva y envuélvalos en papel de aluminio. Caliente una cazuela grande con agua y sal y cueza los muslos dentro durante 90 minutos. Reserve 4 cucharadas de la mezcla del queso y hierva el resto con los dados de chalote, la nata y el vino blanco. Para servir forme bolitas con 1 cucharada de la mezcla de queso, retire el papel de aluminio de los muslos y póngalos en un plato. Vierta por encima la salsa. Decore con los berros y algunas hojas de menta. Un buen acompañamiento son albóndigas de pan en rodajas.

4 cosce di lepre
1 rotolo di formaggio di capra da ca. 200 g
1 mazzetto di menta piperita tritata
1 scalogno tritato
500 ml di panna
100 ml di vino bianco
2 cucchiai di olio d'oliva
Sale, pepe
Crescione d'acqua e foglie di menta per decorare

Mescolate la menta al formaggio di capra, salate e pepate e mettete a raffreddare. Disossate le cosce di lepre, conditele, sfregatele con l'olio di oliva e avvolgetele in carta alluminio. In una pentola grande scaldate dell'acqua salata e lessatevi le cosce di lepre per 90 minuti. Tenete da parte 4 cucchiai del composto di formaggio di capra, portate a bollore il resto del formaggio con i dadini di scalogno, la panna e il vino bianco. Prima di servire, mettete su ogni piatto 1 grossa noce di formaggio di capra, togliete le cosce di lepre dalla carta alluminio, sistemate una coscia vicino al formaggio e versate su tutto il piatto alcune gocce di salsa. Guarnite con crescione d'acqua e alcune foglie di menta. Potete accompagnare la pietanza con Serviettenknödel (gnocchi di pane bolliti in un canovaccio).

Costes

Design: Jaques García | Chef: Mr. Coly
Owner: Jean Louis Costes

239, Rue Saint-Honoré | 75001 Paris | 1ère arrondissement
Phone: +33 1 42 44 50 25
www.hotelcostes.com | remarks@hotelcostes.com
Metro: Concorde, Tuileries
Opening hours: Mon–Sun 7 am to 2 am
Average price: € 80
Cuisine: Classical

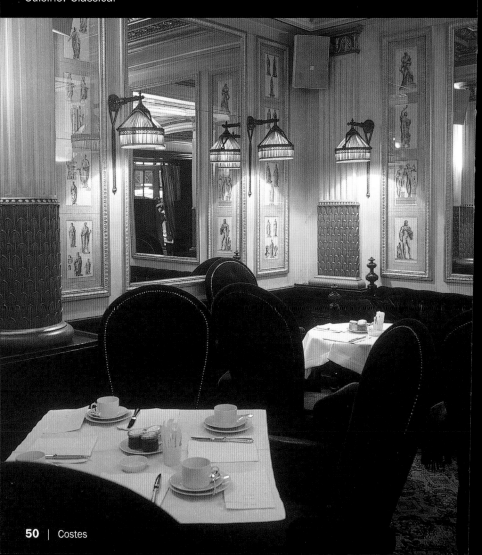

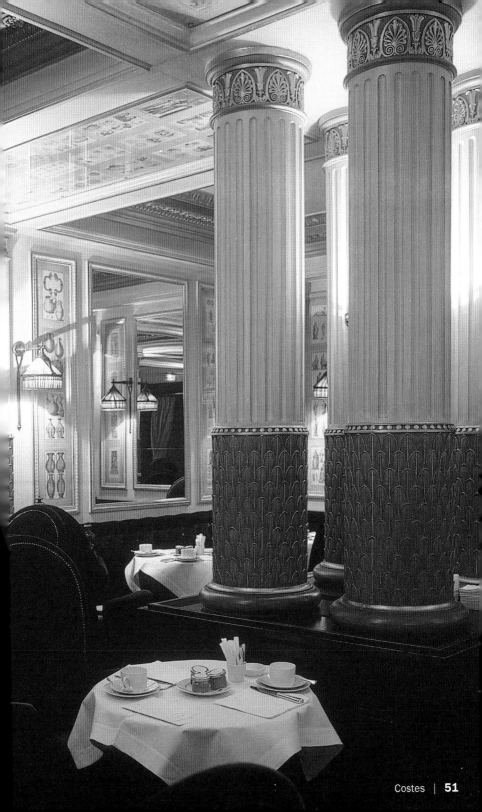

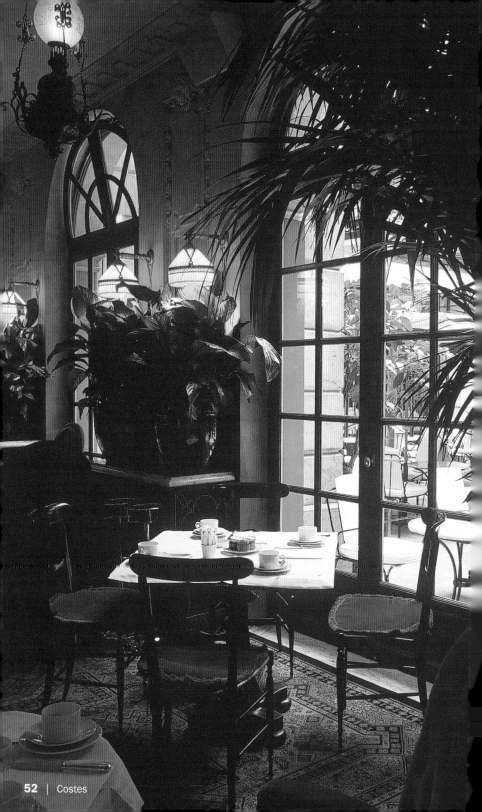

Strawberry Daiquiri

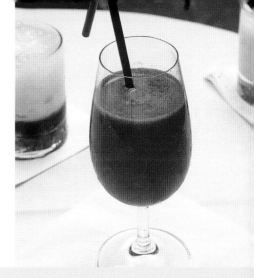

4 cl de rhum blanc
1 c. à soupe de sirop de sucre
1 cl de jus de citron
3 fraises
Glace pilée

Mélanger tous les ingrédients dans un mixeur pour liquéfier. Servir dans un verre à cocktail rafraîchi et garnir d'une paille.

4 cl white rum
1 tbsp sugar syrup
1 cl lemon juice
3 strawberries
Crushed ice

Combine all ingredients in a blender and mix until smooth. Pour into a chilled cocktail glass and garnish with a straw.

4 cl weißer Rum
1 EL Zuckersirup
1 cl Zitronensaft
3 Erdbeeren
Crush-Eis

Alle Zutaten in einen Mixer geben und pürieren. In ein kaltes Cocktailglas füllen und mit einem Strohhalm garnieren.

4 cl de ron blanco
1 cucharada de sirope de azúcar
1 cl de zumo de limón
3 fresas
Hielo picado

Triture todos los ingredientes en la batidora. Ponga la mezcla en un vaso de cóctel helado y adorne con una pajita.

4 cl di rum bianco
1 cucchiaio di sciroppo di zucchero
1 cl di succo di limone
3 fragole
Ghiaccio tritato

Mettete tutti gli ingredienti in un frullatore e frullateli bene. Versate in un bicchiere da cocktail ghiacciato e guarnite con una cannuccia.

Etienne-Marcel

Design: M & M, Philippe Parreno, Pierre Huyghe, Anna Léna Vaney
Chef: Xavier Etchebès | Owner: Nora Mahdjoub

34, Rue Étienne-Marcel | 75002 Paris | 2e arrondissement
Phone: +33 1 45 08 01 03
Metro: Étienne-Marcel
Opening hours: Tue–Sat 9 am to 3:30 am, Sun–Wed 9 am to 2 am
Average price: € 50
Cuisine: French

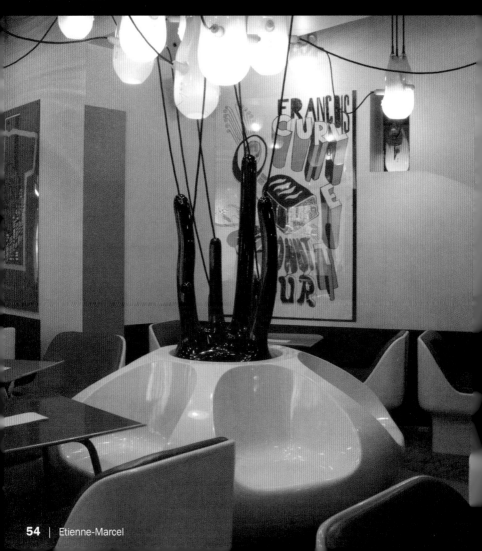

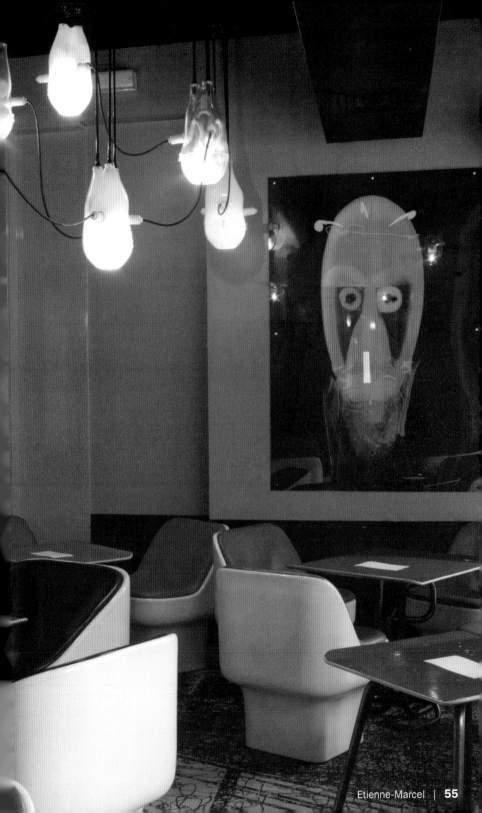

Fontaine Gaillon

Chef: Laurent Audiot | Owners: Gérard Depardieu, Laurent Audiot

Place Gaillon | 75002 Paris | 2e arrondissement
Phone: +33 1 47 42 63 22
Metro: Opéra
Opening hours: Mon–Fri noon to 2:30 pm, 7 pm to midnight
Average price: € 30
Cuisine: French

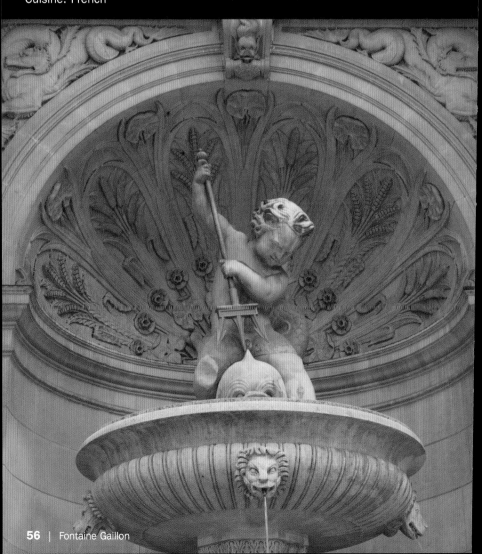

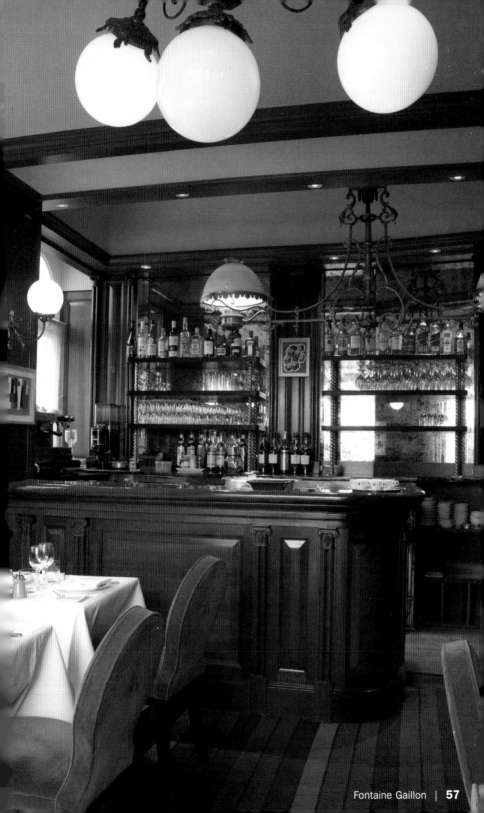

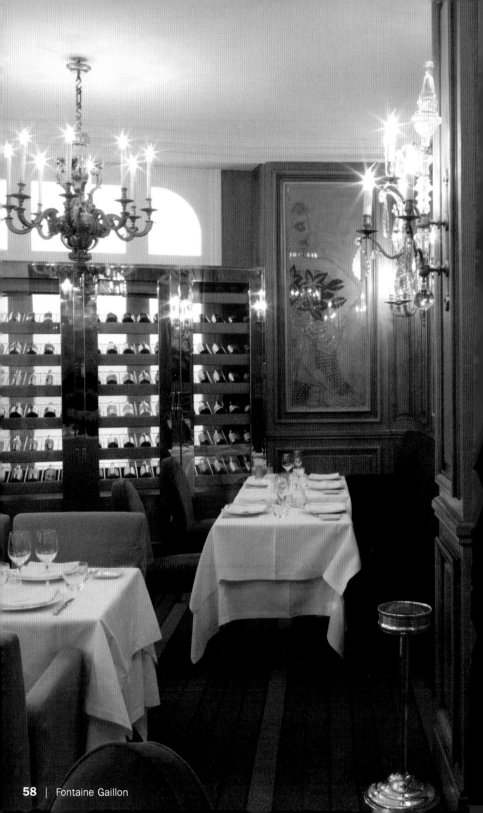

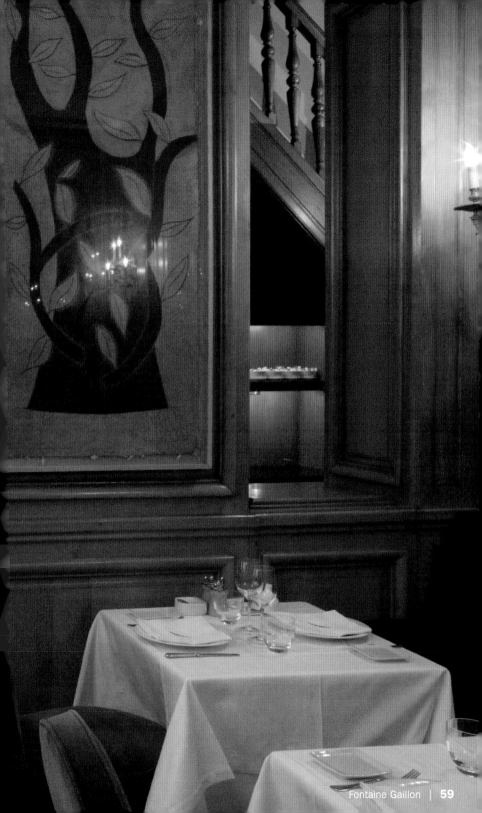

Raviolis
aux scampis et au persil

Ravioli with Scampi and Parsley
Ravioli mit Scampi und Petersilie
Raviolis con gambas y perejil
Ravioli di scampi e prezzemolo

20 scampis décortiqués
20 feuilles de persil
20 feuilles de lasagne fraîches
Sel, poivre
1 jaune d'œuf

3 c. à soupe de beurre
Jus d'un demi citron
Sel, poivre

Étaler les feuilles de lasagne, déposer sur chaque feuille un scampi et une feuille de persil, saler et poivrer ; badigeonner les bords de jaune d'œuf et fermer les lasagnes. Porter à ébullition un faitout d'eau salée, cuire les raviolis env. 2 minutes. Entre temps faire fondre le beurre dans une grande poêle, ajouter le jus de citron, du sel et du poivre. Sortir les raviolis de l'eau et les poêler rapidement à feu vif. Disposer cinq raviolis dans une assiette creuse et arroser de beurre de citron.

20 scampi, peeled
20 parsley leaves
20 fresh lasagna sheets
Salt, pepper
1 egg yolk

3 tbsp butter
Juice of ½ lemon
Salt, pepper

Spread the lasagna sheets, and top each shee⸱ with a scampi and a parsley leave, season wit⸱ salt and pepper, brush the edges with egg yol⸱ and fold the lasagna sheet together. Bring plent⸱ of salted water to a boil, and simmer the ravio⸱ for approx. two minutes. In the meantime me⸱ the butter in a large pan, stir in the lemon juic⸱ and season with salt and pepper. Drain the ravio⸱ and put in the pan. Turn over in the butter an⸱ place five ravioli in every deep plate. Drizzle wit⸱ lemon butter.

20 Scampi, geschält
20 Petersilienblätter
20 frische Lasagneblätter
Salz, Pfeffer
1 Eigelb

3 EL Butter
Saft einer halben Zitrone
Salz, Pfeffer

Lasagneblätter ausbreiten, auf jedes Lasagneblatt einen Scampi und ein Petersilienblatt geben, mit Salz und Pfeffer würzen, die Ränder mit Eigelb bestreichen und das Lasagneblatt zuklappen. Reichlich Salzwasser zum Kochen bringen, die Ravioli darin ca. zwei Minuten gar ziehen lassen. In der Zwischenzeit die Butter in einer großen Pfanne schmelzen lassen, den Zitronensaft unterrühren und mit Salz und Pfeffer abschmecken. Die Ravioli aus dem Wasser nehmen und in die Pfanne geben. In der Butter schwenken und jeweils fünf Ravioli in einen tiefen Teller geben. Mit der Zitronenbutter beträufeln.

20 gambas, peladas
20 hojas de perejil
20 láminas frescas de lasaña
Sal, pimienta
1 yema

3 cucharadas de mantequilla
Zumo de medio limón
Sal, pimienta

Extienda las láminas de la lasaña y coloque sobre cada una de ellas una gamba y una hoja de perejil, salpimiente, pinte los bordes con la yema y cierre las láminas. Lleve bastante agua a ebullición y hierva dentro los ravioli durante aprox. 2 minutos hasta que estén en su punto. En ese tiempo derrita la mantequilla en una sartén grande, añada el zumo de limón removiendo y salpimiente. Saque los ravioli del agua y póngalos en la sartén. Saltéelos en la mantequilla y ponga cinco ravioli en cada uno de los platos hondos. Vierta por encima la mantequilla con limón.

20 scampi sgusciati
20 foglie di prezzemolo
20 sfoglie di lasagne fresche
Sale, pepe
1 tuorlo d'uovo

3 cucchiai di burro
Succo di mezzo limone
Sale, pepe

Aprite le sfoglie di lasagne, mettete su ogni sfoglia uno scampo e una foglia di prezzemolo, salate e pepate, spennellate il tuorlo d'uovo sui bordi della sfoglia e chiudetela. Portate ad ebollizione abbondante acqua salata, versatevi quindi i ravioli e lasciateli sobbollire per ca. 2 minuti. Nel frattempo fate sciogliere il burro in una padella grande, incorporatevi il succo di limone e correggete di sale e pepe. Togliete i ravioli dall'acqua, versateli nella padella e fateli saltare nel burro. Mettete quindi 5 ravioli in ogni piatto fondo e versatevi alcune gocce di burro al limone.

Georges

Design: Jakob & MacFarlane | Chef: Jean-Philippe Leboeuf

Centre Pompidou, 6th floor, 19, Rue Beaubourg | 75004 Paris | 4e arrondissement
Phone: +33 1 44 78 47 99
Metro: Rambuteau
Opening hours: Wed–Mon noon to 1 am
Average price: € 60
Cuisine: French, contemporary

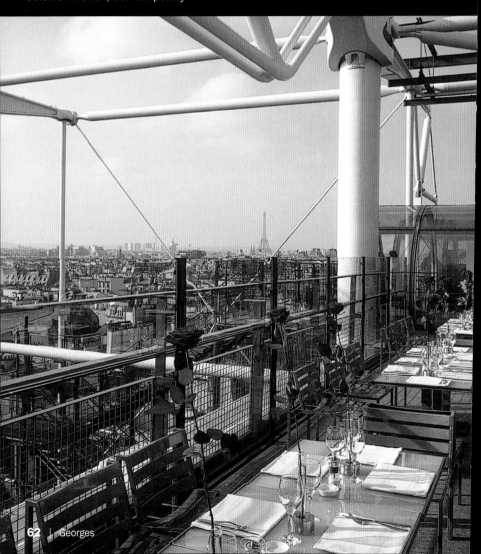

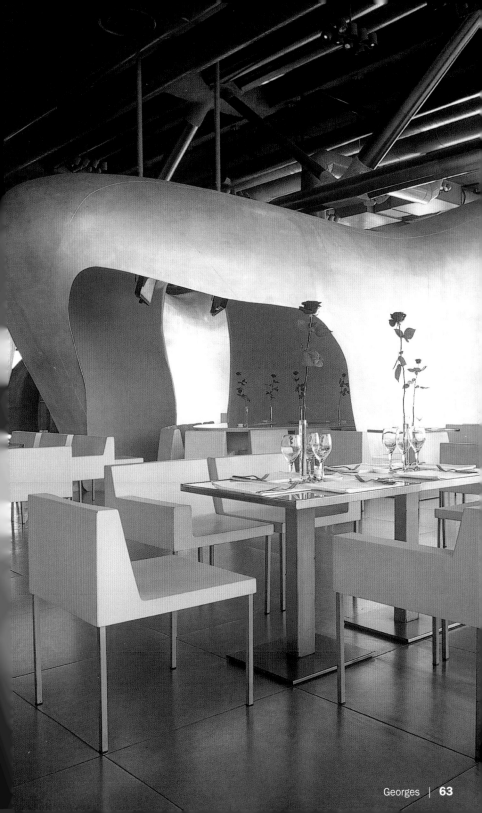

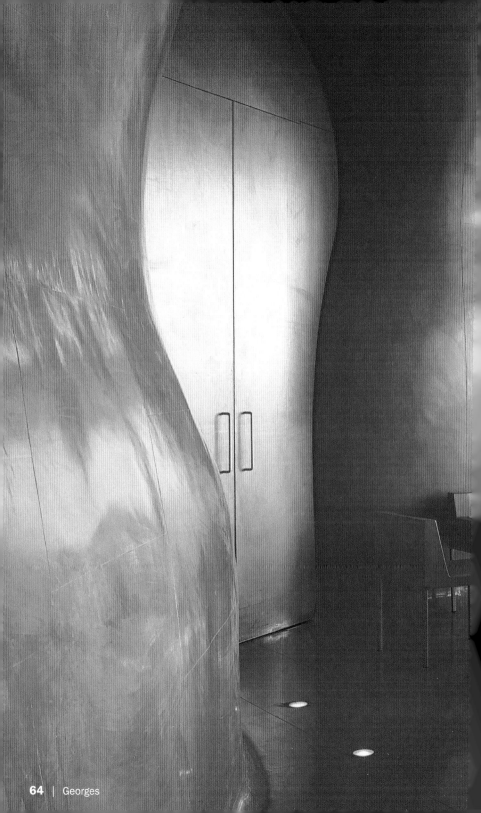

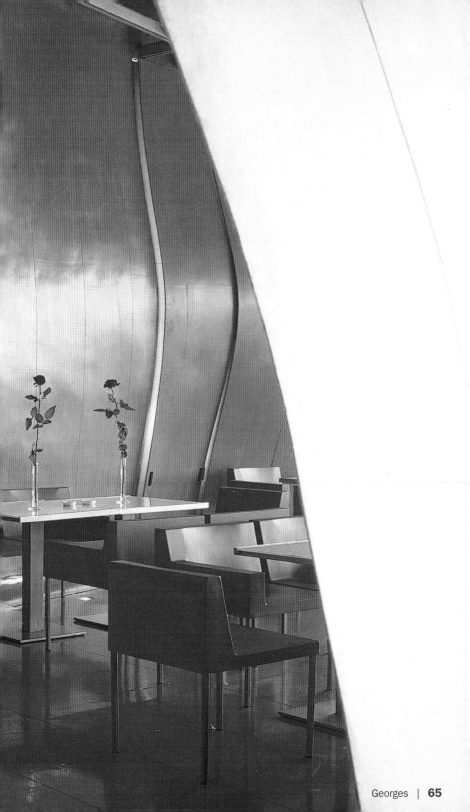

Harry's Bar

Design: Old Time Prohibition | Chef: Miss Estrella
Owner: Mac Elhone 4th generation

5, Rue Daunou | 75002 Paris | 2e arrondissement
Phone: +33 1 42 61 71 14
www.harrysbar.fr | info@harrys-bar.fr
Metro: Opéra, Pyramides
Opening hours: Every day 10:30 am to 4 am, piano bar 10 pm to 3 am,
lunch Mon–Fri noon to 3 pm
Average price: € 10,50
Cuisine: Cocktails
Special features: Birthplace of the brilliant Bloody Mary & White Lady, piano bar

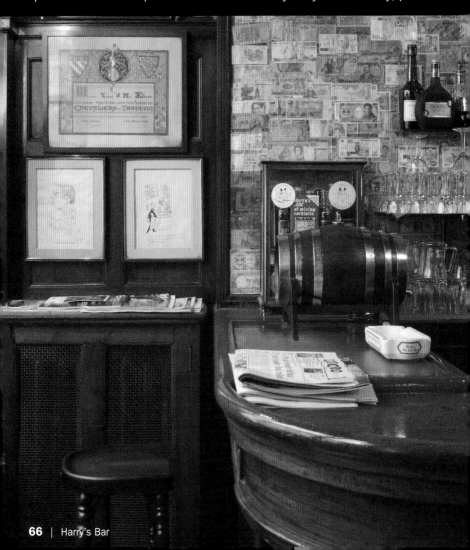

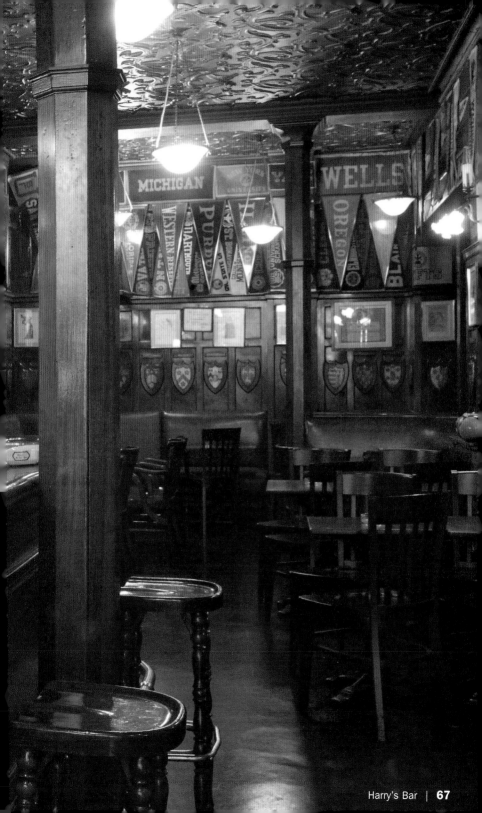

Antoniño

1 cl de lime cordial
3 cl de liqueur de marasquin
6 cl de rhum cubain
1 lamelle de zeste de limette
1 cure dent

Bien mélanger tous les ingrédients et piquer le zeste de limette avec le cure dent. Servir le cocktail dans un verre à martini et y plonger le zeste de limette.

1 cl Lime Cordial
3 cl Maraschino liqueur
6 cl Cuban rum
1 piece lime peel
1 tooth pick

Mix all ingredients and place the lime peel on the tooth pick. Pour the cocktail in a martini glass and put the lime peel in the cocktail.

1 cl Lime Cordial
3 cl Maraschino Likör
6 cl Kubanischer Rum
1 Stück Limettenschale
1 Zahnstocher

Alle Zutaten miteinander verrühren und die Limettenschale auf den Zahnstocher stecken. Den Cocktail in ein Martiniglas geben und die Limettenschale hineinlegen.

1 cl de Lime Cordial
3 cl de licor Maraschino
6 cl de ron cubano
1 trozo de piel de lima
1 palillo

Mezcle todos los ingredientes e inserte el palillo en la piel de la lima. Sirva el cóctel en un vaso de martini e introduzca dentro la piel de lima.

1 cl di Lime Cordial
3 cl di Maraschino
6 cl di rum cubano
1 pezzetto di scorza di limetta
1 stecchino

Mescolate bene tutti gli ingredienti e infilate la scorza di limetta nello stecchino. Versate il cocktail in un bicchiere da Martini e immergetevi dentro la scorza di limetta.

Kong

Design: Philippe Starck | Chef: Richard Pommiès
Owner: Gérald Collet

1, Rue du Pont-Neuf | 75001 Paris | 1er arrondissement
Phone: +33 1 40 39 09 00
www.kong.fr
Metro: Pont-Neuf
Opening hours: Mon–Sun 10 am to 2 am
Average price: € 40
Cuisine: French, Japanese

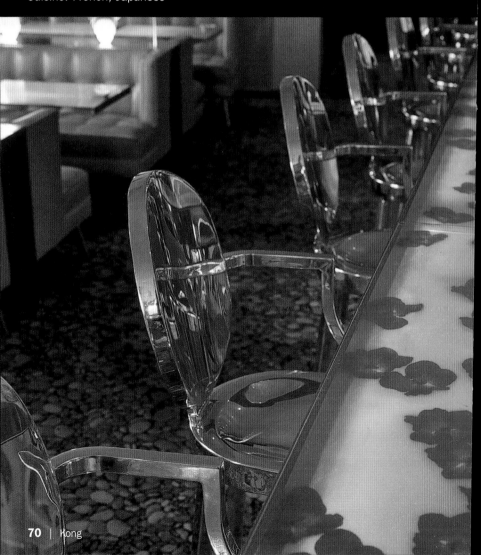

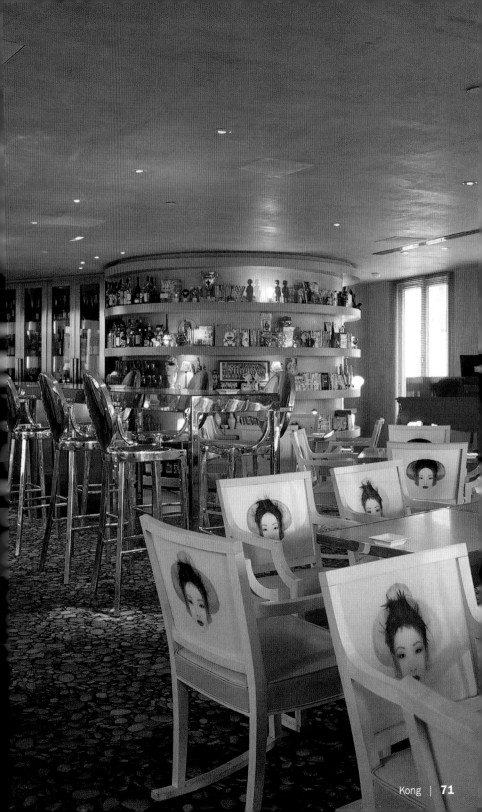

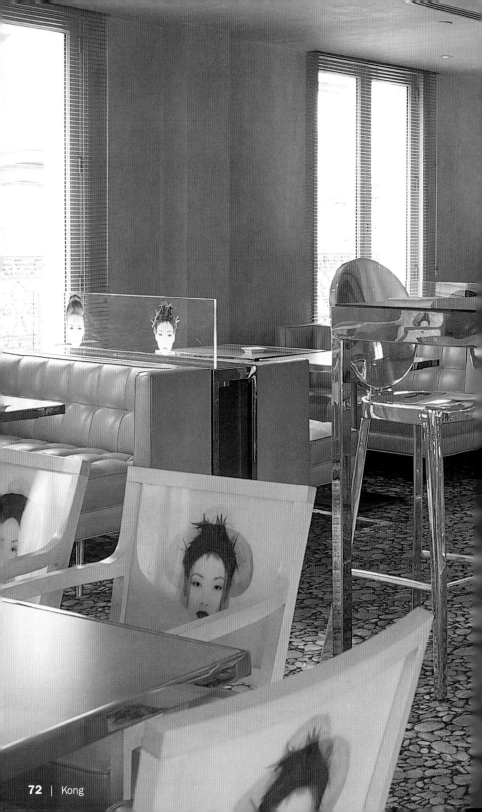

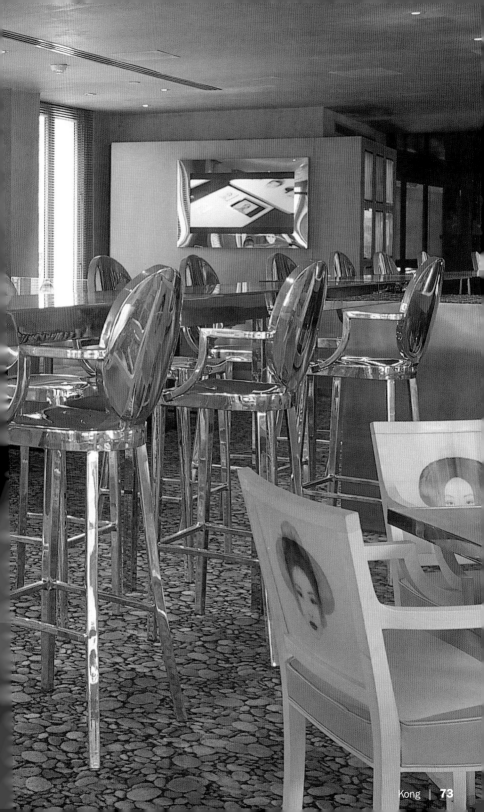

La
Cantine du Faubourg

105, Rue du Faubourg Saint-Honoré | 75008 Paris | 8e arrondissement
Phone: +33 1 42 56 22 22
www.lacantine.com
Metro: Saint-Philippe-du-Roule
Opening hours: Mon–Sun 11 am to 4 am
Average price: € 55
Cuisine: International
Special features: Live music

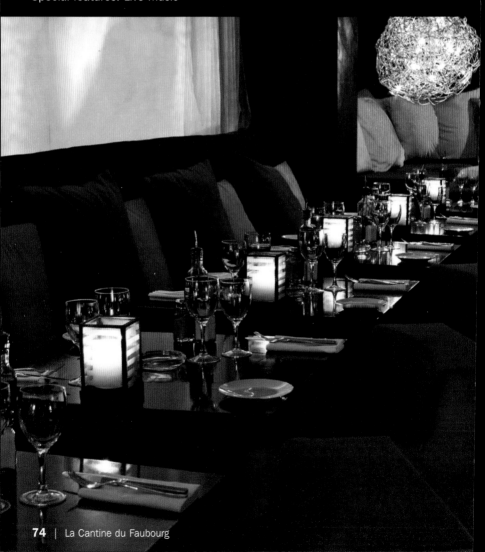

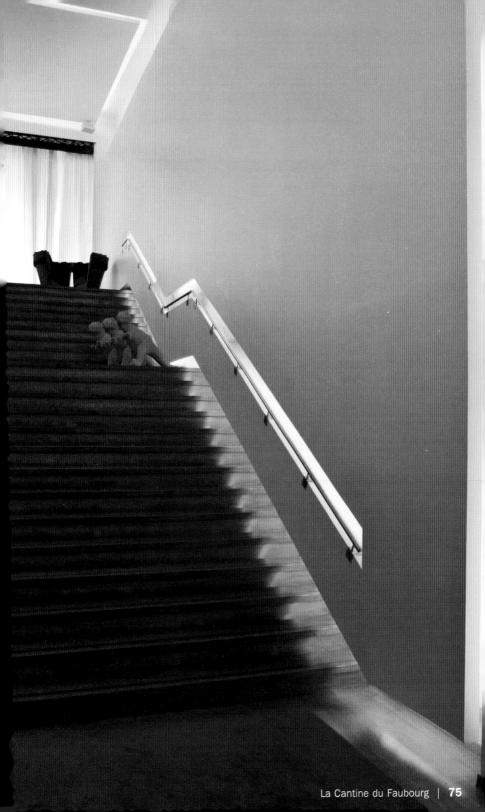

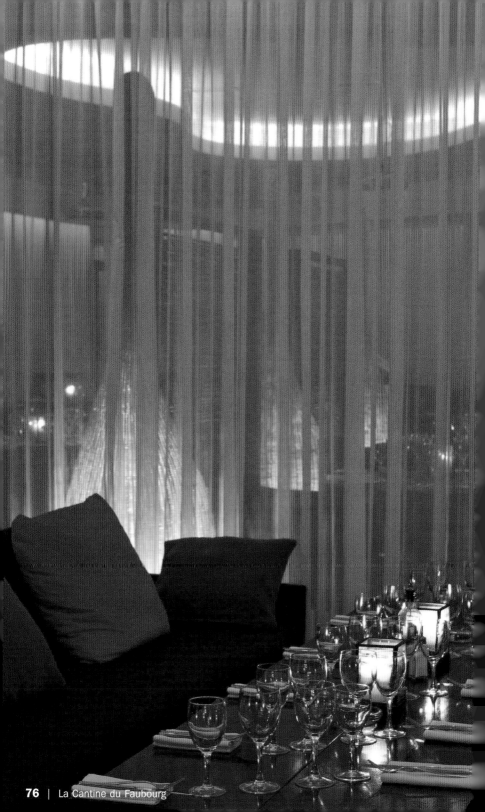

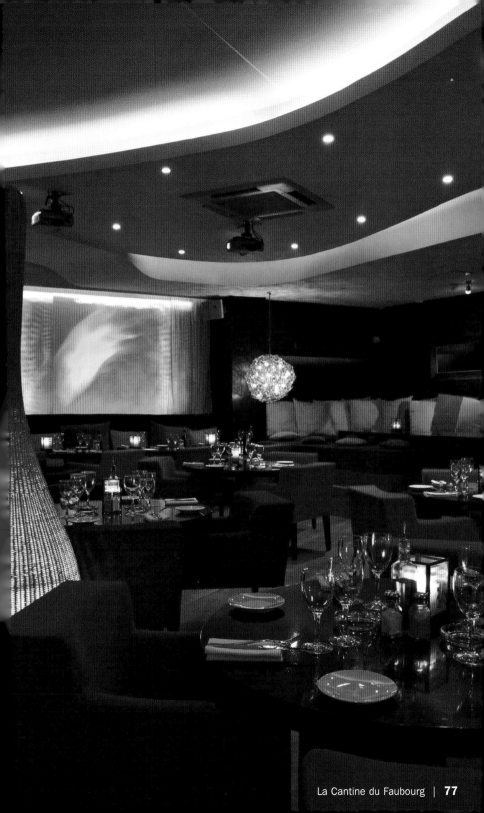

Gambas grillées
et purée de patates douces

Grilled Gambas with Yam Puree

Gegrillte Gambas mit Süßkartoffelpüree

Langostas a la parilla con puré de patata dulce

Gamberoni alla piastra con purè di patate dolci

4 gambas de 200 g chacune
2 c. à café d'épices cajun (mélange d'épices)
600 g de patates douces épluchées, en cubes
200 ml de bouillon de volaille
1 c. à café de curcuma
1 poivron rouge épépiné, en dés
2 oignons en dés
1 tomate en dés
5 c. à soupe d'huile d'olive
2 c. à soupe de sauce de soja
240 ml de fond de veau
1 pincée de piment
6 c. à soupe de beurre
Ciboulette pour la décoration
Sel, poivre

Décortiquer les gambas, retirer le filament noir dorsal et badigeonner d'épices cajun et de 2 c. à soupe d'huile d'olive. Mettre au frais. Faire revenir un oignon en dés dans 3 c. à soupe de beurre, ajouter les patates douces et arroser de bouillon de volaille. Laisser mijoter. Pour la sauce, faire revenir le poivron, un oignon en dés et la tomate dans 3 c. à soupe d'huile d'olive, déglacer avec la sauce de soja et mouiller avec le fond de veau. Laisser mijoter à feu doux. Faire une purée avec les patates douces, saler, poivrer, assaisonner de curcuma et conserver au chaud. Passer la sauce au chinois, rectifier l'assaisonnement avec le piment, 3 c. à soupe de beurre, du sel et du poivre. Poêler les gambas à feu vif, les disposer sur les assiettes avec respectivement deux quenelles de purée. Garnir de sauce et décorer de ciboulette.

4 gambas, 6 ½ oz each
2 tsp cajun (spice mix)
20 oz yams, peeled and diced
200 ml chicken stock
1 tsp curcuma
1 red bell pepper, seeded and diced
2 onions, diced
1 tomato, diced
5 tbsp olive oil
2 tbsp soy sauce
240 ml veal fond
Pinch pimento
6 tbsp butter
Chives for decoration
Salt, pepper

Peel the tails of the gambas, remove the guts and rub with cajun and 2 tbsp olive. Chill. Sauté one diced onion in 3 tbsp butter, add the yams and fill up with chicken stock. Let simmer until tender. For the sauce, sauté the bell pepper, one diced onion and the tomatoes in 3 tbsp olive oil, quench with soy sauce and fill up with veal fond. Let simmer gently. Mash the yams, season with salt, pepper and curcuma and keep warm. Pour the sauce through a strainer, season with pimento, 3 tbsp butter, salt and pepper. Sear the gambas, arrange with two scoops of yam puree on the plates and garnish with sauce and chives.

4 Gambas, à 200 g
2 TL Cajun (Gewürzmischung)
600 g Süßkartoffeln, geschält und gewürfelt
200 ml Geflügelbrühe
1 TL Kurkuma
1 rote Paprika, entkernt und gewürfelt
2 Zwiebeln, gewürfelt
1 Tomate, gewürfelt
5 EL Olivenöl
2 EL Sojasauce
240 ml Kalbsfond
Prise Piment
6 EL Butter
Schnittlauch zur Dekoration
Salz, Pfeffer

Die Schwänze der Gambas schälen, den Darm entfernen und mit Cajun und 2 EL Olivenöl einreiben. Kaltstellen. Eine gewürfelte Zwiebel in 3 EL Butter anschwitzen, die Süßkartoffeln zugeben und mit Geflügelbrühe aufgießen. Weichkochen lassen. Für die Sauce die Paprika, eine gewürfelte Zwiebel und die Tomate in 3 EL Olivenöl anschwitzen, mit Sojasauce ablöschen und mit Kalbsfond aufgießen. Leise köcheln lassen. Die Süßkartoffeln pürieren, mit Salz, Pfeffer und Kurkuma würzen und warm stellen. Die Sauce durch ein Sieb gießen, mit Piment, 3 EL Butter, Salz und Pfeffer abschmecken. Die Gambas scharf anbraten, mit je zwei Nocken Süßkartoffelpüree auf den Tellern anrichten und mit Sauce und Schnittlauch garnieren.

4 langostas, de 200 g cada una
2 cucharaditas de Cajún (mezcla de especias)
600 g de patatas dulces, peladas y en dados
200 ml de caldo de volatería
1 cucharadita de cúrcuma
1 pimiento rojo, despepitado y en dados
2 cebollas, en dados
1 tomate, en dado
5 cucharadas de aceite de oliva
2 cucharadas de salsa de soja
240 ml de fondo de ternera
1 pizca de pimentón
6 cucharadas mantequilla
Cebollino para decorar
Sal, pimienta

Pele las colas de los langostinos, elimine el intestino y frótelas con Cajún y 2 cucharadas de aceite de oliva. Reserve en un lugar frío. Rehogue una cebolla en dados en 3 cucharadas de mantequilla, añada las patatas e incorpore el caldo de volatería. Cueza hasta que las patatas estén tiernas. Para preparar la salsa rehogue el pimiento, una cebolla en dados y el tomate en 3 cucharadas de aceite de oliva, añada la salsa de soja y vierta dentro el fondo de ternera. Deje que cueza a fuego lento. Haga puré las patatas, condimente con la sal, la pimienta y la cúrcuma y reserve caliente. Pase la salsa por el colador y sazone con el pimentón, 3 cucharadas de mantequilla, sal y pimienta. Fría las langostas a fuego fuerte, póngalas en los platos con dos bolitas del puré de patata y decore con la salsa y cebollino.

4 gamberoni da 200 g l'uno
2 cucchiaini di cajun (miscela di spezie)
600 g di patate dolci pelate e tagliate a dadini
200 ml di brodo di pollo
1 cucchiaino di curcuma
1 peperone rosso privato dei semi e tagliato a dadini
2 cipolle tagliate a dadini
1 pomodoro tagliato a dadini
5 cucchiai di olio d'oliva
2 cucchiai di salsa di soia
240 ml di fondo di cottura di vitello
Pizzico di pimento
6 cucchiai di burro
Erba cipollina per decorare
Sale, pepe

Sgusciate le code dei gamberoni, privateli dell'intestino e sfregateli con le spezie cajun e 2 cucchiai di olio d'oliva. Metteteli a raffreddare. Fate imbiondire una cipolla tagliata a dadini in 3 cucchiai di burro, aggiungete le patate dolci e versatevi sopra il brodo di pollo. Lasciate cuocere bene a fuoco lento. Per la salsa fate soffriggere in 3 cucchiai di olio d'oliva il peperone, l'altra cipolla tagliata a dadini e il pomodoro, bagnate con la salsa di soia e versatevi il fondo di cottura di vitello. Lasciate crogiolare. Riducete in purea le patate dolci, condite con sale, pepe e curcuma, mettete in caldo. Passate la salsa in un colino, insaporite con il pimento e 3 cucchiai di burro, correggete di sale e pepe. Fate rosolare bene i gamberoni, disponeteli sui piatti con due grosse noci di purè di patate dolci e guarnite con salsa ed erba cipollina.

La Gare

Design: Studio Marc Hertrich
Chef: Yann Morel | Owner: Robert Bouchard

19, Chaussée de la Muette | 75016 Paris | 16e arrondissement
Phone: +33 1 42 15 15 31
www.restaurantlagare.com
Metro: La Muette
Opening hours: Mon–Sun noon to 3 pm, 7 pm to 11 pm
Average price: € 50
Cuisine: French

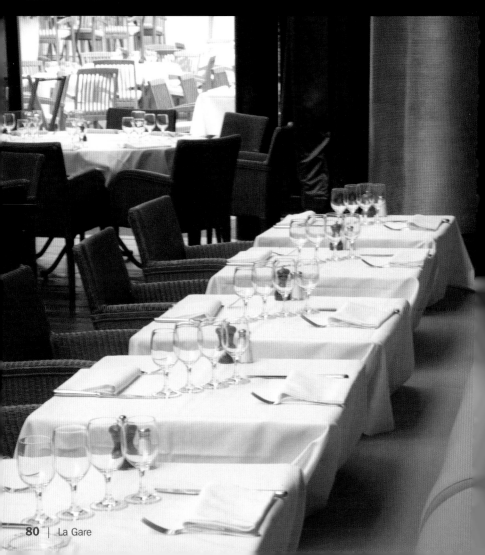

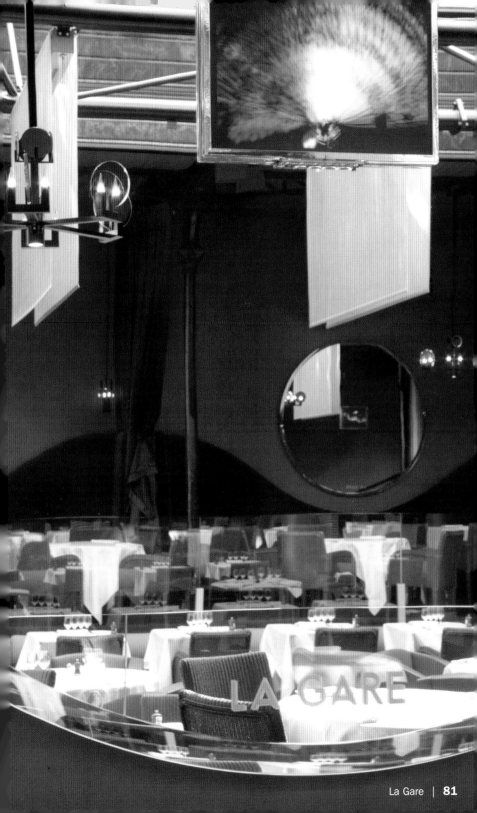

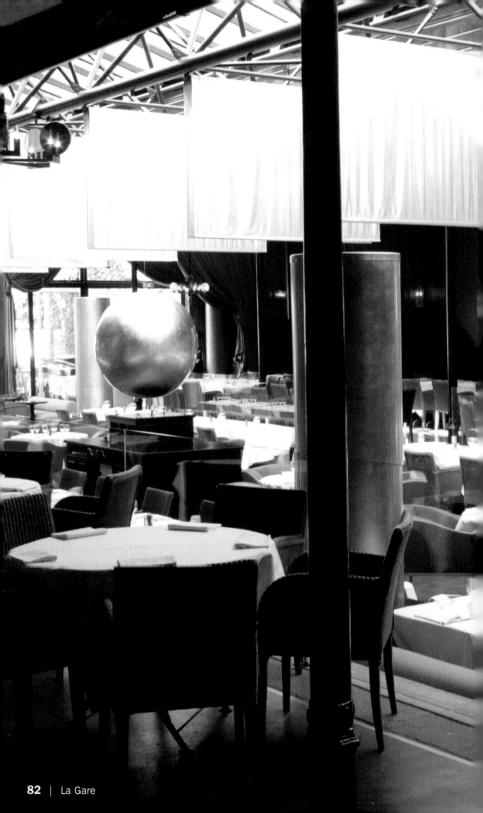

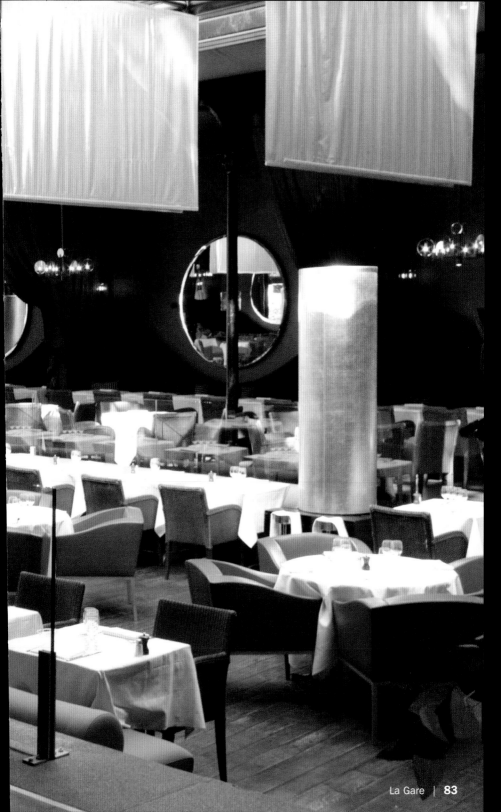

Crabe à la pomme verte et au concombre

Crab Meat with Green Apple and Cucumber

Krebsfleisch mit grünem Apfel und Gurke

Carne de cangrejo con manzana verde y pepino

Polpa di granchio con mela verde e cetriolo

200 g de petits pois frais
150 ml de crème
2 branches de sarriette
Sel, poivre

1 crabe cuit au court bouillon, décortiqué, en dés
1 araignée de mer cuite au court bouillon, décortiquée, en dés
1 pomme épépinée en dés
1 petit concombre épépiné, en dés
4 c. à soupe d'herbes mélangées (ciboulette, cerfeuil, persil, etc.)
1 c. à soupe de moutarde
5 c. à soupe d'huile d'olive
4 crackers au cumin

Cuire les petits pois à l'anglaise et les réduire en purée avec la crème, assaisonner de sarriette, de sel et de poivre et répartir dans quatre verrines. Mettre au frais. Mélanger la chair du crabe et de l'araignée de mer avec les dés de pomme et de concombre, ajouter la vinaigrette d'herbes mélangées, de moutarde et d'huile d'olive et rectifier l'assaisonnement. Répartir sur la purée de petit pois dans les verrines et servir avec des crackers au cumin.

6 ½ oz fresh peas
150 ml cream
2 twigs savory
Salt, pepper

1 crab, cooked, shelled and diced
1 spider crab, cooked, shelled and diced
1 apple, seeded and diced
1 small cucumber, seeded and diced
4 tbsp herb mix (chives, chervil, parsley, etc.)
1 tbsp mustard
5 tbsp olive oil
4 cumin crackers

Cook the peas with the cream until it resembles a puree, season with savory, salt and pepper and pour into four preservative glasses. Chill. Combine the crab and spider crab meat with the diced apple and the diced cucumber, stir in herb mix, mustard and olive oil and season. Pour on top of the pea puree and serve with cumin crackers.

200 g frische Erbsen
150 ml Sahne
2 Zweige Bohnenkraut
Salz, Pfeffer

1 Krebs, abgekocht, ausgelöst und gewürfelt
1 Meeresspinne, abgekocht, ausgelöst und gewürfelt
1 Apfel, entkernt und gewürfelt
1 kleine Gurke, entkernt und gewürfelt
4 EL Kräutermischung (Schnittlauch, Kerbel,
Petersilie, etc.)
1 EL Senf
5 EL Olivenöl
4 Kreuzkümmelcräcker

Die Erbsen mit der Sahne zu einem Püree einkochen, mit Bohnenkraut, Salz und Pfeffer würzen und in vier Einmachgläser füllen. Kaltstellen. Krebs- und Meeresspinnenfleisch mit Apfelwürfeln und Gurkenwürfeln mischen, Kräutermischung, Senf und Olivenöl unterrühren und abschmecken. Auf das Erbsenpüree in die Gläser geben und mit Kreuzkümmelcräckern servieren.

200 g de guisantes frescos
150 ml de nata
2 ramas de ajedrea
Sal, pimienta

1 cangrejo, cocido, pelado y en dados
1 centollo, cocido, pelado y en dados
1 manzana, despepitada y en dados
1 pepino pequeño, despepitado y en dados
4 cucharadas de mezcla de hierbas (cebollino,
perifollo, perejil, etc.)
1 cucharada de mostaza
5 cucharadas de aceite de oliva
4 galletas de comino

Hierva los guisantes con la nata y haga puré, condimente con la ajedrea, la sal y la pimienta y rellene cuatro vasos de conservas. Reserve en frío. Mezcle la carne de cangrejo y de centollo con los dados de manzana y de pepino. Mezcle las hierbas con la mostaza y el aceite de oliva y sazone. Introduzca la mezcla en los vasos, encima del puré de guisantes, y sirva con las galletas de comino.

200 g di piselli freschi
150 ml di panna
2 rametti di santoreggia
Sale, pepe

1 granchio lessato, privato della corazza e tagliato
a dadini
1 grancevola lessata, privata della corazza e
tagliata a dadini
1 mela privata dei semi e tagliata a dadini
1 cetriolo piccolo privato dei semi e tagliato a dadini
4 cucchiai di miscela di erbe aromatiche (erba
cipollina, cerfoglio, prezzemolo, ecc.)
1 cucchiaio di senape
5 cucchiai di olio d'oliva
4 cracker al cumino

Fate cuocere i piselli nella panna fino ad ottenere una purea, condite con la santoreggia, salate e pepate e versate in quattro vasetti da conserva. Mettete a raffreddare. Mescolate la polpa di granchio e di grancevola ai dadini di mela e cetriolo, incorporatevi la miscela di erbe aromatiche, la senape e l'olio d'oliva e correggete di sapore. Versate nei vasetti sulla purea di piselli e servite con cracker al cumino.

La Suite

Design: Imaad Rahmouni | Owner: Cathy Guetta

40, Avenue Georges V | 75008 Paris | 8e arrondissement
Phone: +33 1 53 57 49 49
www.lasuite.fr | pb.lasuite@wanadoo.fr
Metro: George V
Opening hours: Mon–Fri noon to 3 pm, Mon–Sun 8 pm to midnight
Average price: € 60
Cuisine: French with Mediterranean influence

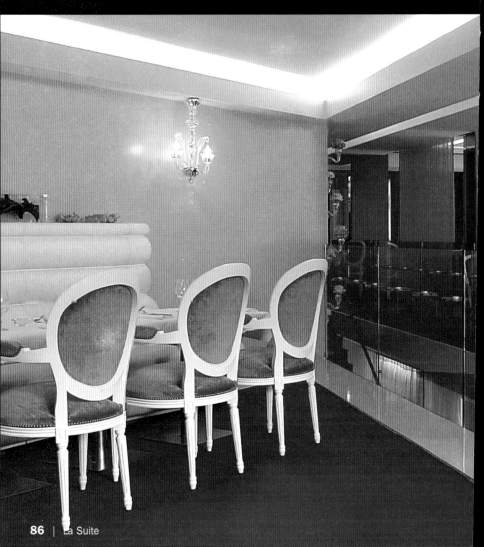

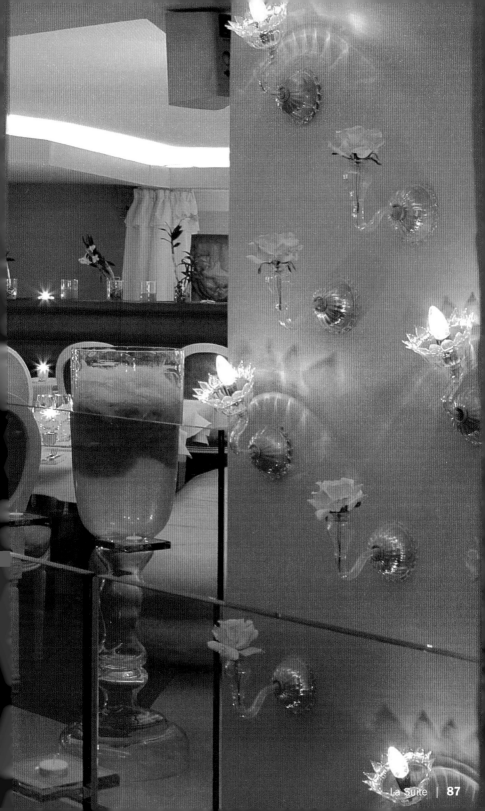

La Suite | **87**

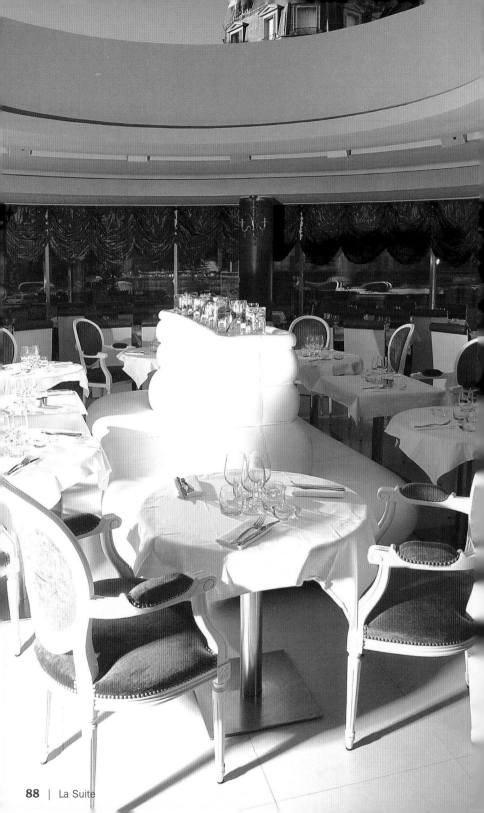

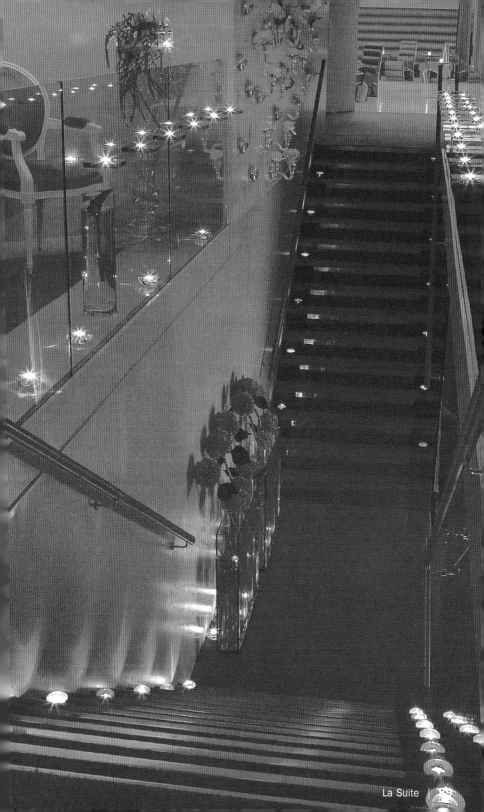

Le Murat

Design: Jaques García | Chef: Philippe Quemard
Owners: Jean-Louis Costes, Raphaël de Montrémy

1, Boulevard Murat | 75016 Paris | 16e arrondissement
Phone: +33 1 46 51 33 17
Metro: Porte d'Auteuil
Opening hours: Mon–Sun 11:30 am to 12:30 am
Average price: € 45
Cuisine: French

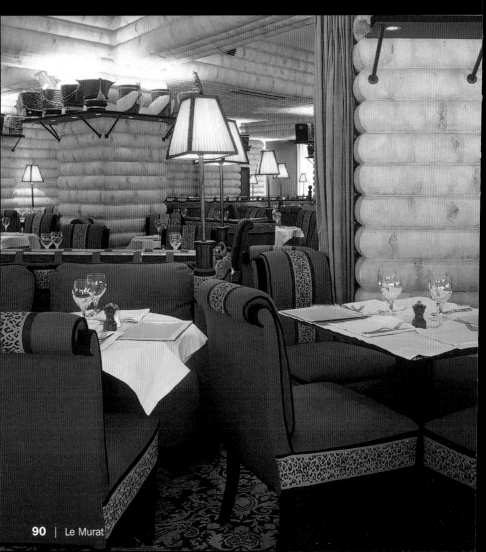

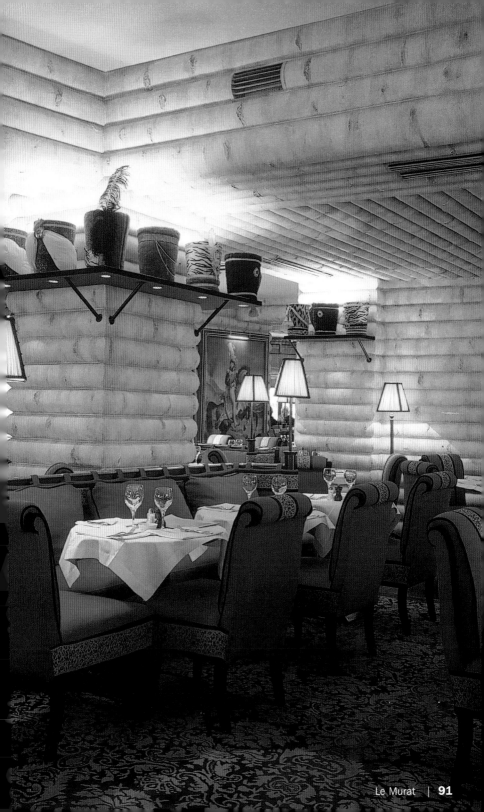

Le Train Bleu

Design: Belle Époque | Chef: Jean-Pierre Hocquet
Owner: Régis Bourdon

Place Louis Armand | 75012 Paris | 12e arrondissement
Phone: +33 1 43 43 09 06
www.le-train-bleu.com | reservation.trainbleu@ssp.fr
Metro: Gare de Lyon
Opening hours: Mon–Sun lunch 11:30 am to 3 pm, dinner 7 pm to 11 pm,
Mon–Fri bar 7:30 am to 11 pm, Sat–Sun 9 am to 11 pm
Average price: € 48
Cuisine: Traditional French
Special features: Listed historical monument

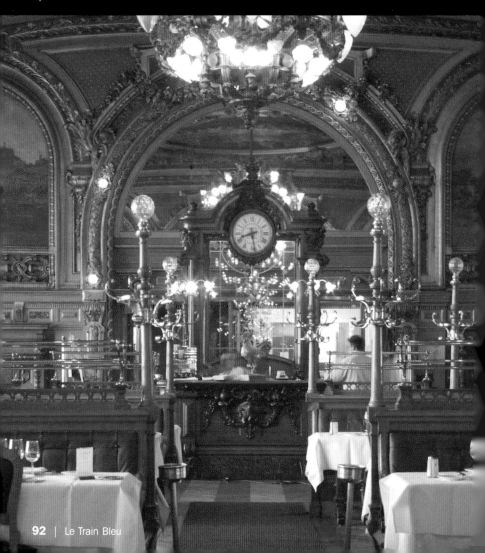

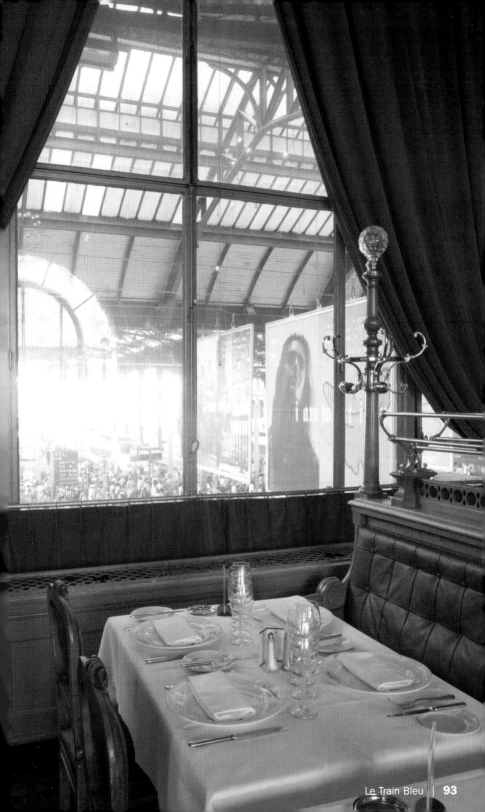

Vacherin meringué

Ice Cream Gateau with Baiser

Eistorte mit Baiser

Tarta helada con merengue

Torta gelato con meringa

100 g de blanc d'oeuf
200 g de sucre
1 pincée de sel
100 g de crème fleurette (crème fraîche liquide à
35 % de matière grasse)
60 g de sucre glace
200 g de framboises
60 g de sucre
Jus d'un citron
4 boules de sorbet de framboises
4 boules de sorbet de citron
Crème anglaise à la vanille toute prête

Monter les blancs en neige avec le sucre et une pincée de sel. Sur une tôle à pâtisserie, façonner à la poche à douille 4 cercles de 10 cm de diamètre et de 2 cm de hauteur. Préchauffer le four à 50 °C. Mettre l'appareil au four et sécher pendant 5 heures. Battre la crème fleurette en chantilly avec le sucre glace. Réduire les framboises en purée avec le sucre et le jus de citron, les passer un chinois. Déposer une boule de sorbet de framboise et une de sorbet de citron sur une meringue. Recouvrir entièrement le sorbet à la poche à douille remplie de chantilly. Mettre au freezer. Sortir le dessert du freezer 5 minutes avant de servir. Décorer les assiettes avec un joli dessin de coulis de framboise et de crème anglaise, disposer le vacherin à côté et saupoudrer le bord des assiettes de cacao en poudre.

3 ½ oz egg whites
6 ½ oz sugar
1 pinch salt
3 ½ oz crème fleurette (liquid crème fraîche with
35 % fat)
2 oz powdered sugar
6 ½ oz raspberries
2 oz sugar
Juice of 1 lemon
4 scoops raspberry sherbet
4 scoops lemon sherbet
Convenience vanilla sauce

Beat the egg whites with sugar and a pinch of salt until stiff. Shape 4 circles with a diameter of 4 inches and a height of ¾ inch on a baking sheet with the help of a pastry bag. Preheat the oven to 120 °F. Place the mixture in the oven and let dry for 5 hours. Beat the crème fleurette with the powdered sugar. Mash the raspberries with sugar and lemon juice and pour through a sieve. Put a scoop of raspberry and lemon sherbet on each meringue and shape the crème fleurette with a pastry bag around it, until the sherbet is totally covered. Freeze. 5 minutes before serving, take the dessert out of the freezer, draw a decorative pattern on the plate with the raspberry and vanilla sauce and arrange the ice cream dessert beside it. Dust the edge of the plate with cacao.

100 g Eiweiß
200 g Zucker
1 Prise Salz
100 g Crème Fleurette (flüssige Crème Fraîche
mit 35 % Fett)
60 g Puderzucker
200 g Himbeeren
60 g Zucker
Saft einer Zitrone
4 Kugeln Himbeersorbet
4 Kugeln Zitronensorbet
Fertige Vanillesauce

Das Eiweiß mit dem Zucker und der Prise Salz zu Schnee schlagen. Mit Hilfe eines Spritzbeutels auf einem Backblech 4 Kreise mit einem Durchmesser von 10 cm und einer Höhe von 2 cm aufspritzen. Den Backofen auf 50 °C vorheizen. Die Masse in den Backofen geben und 5 Stunden lang trocknen lassen. Die Crème Fleurette mit dem Puderzucker schlagen. Die Himbeeren mit dem Zucker und dem Zitronensaft pürieren und durch ein Sieb streichen. Jeweils eine Kugel Himbeer- und Zitronensorbet auf ein Baiser geben und mit einem Spritzbeutel die Crème-Fleurette-Mischung darumspritzen, bis das Sorbet vollständig bedeckt ist. Einfrieren. Zum Servieren das Dessert 5 Minuten vorher aus dem Gefrierfach nehmen, mit der Himbeer- und Vanillesauce ein dekoratives Muster auf den Teller spritzen und das Eisdessert daneben anrichten. Den Rand des Tellers mit Kakao bestäuben.

100 g de claras
200 g azúcar
1 pizca de sal
100 g de Crème Fleurette (nata fresca espesa
con 35 % de grasa)
60 g de azúcar en polvo
200 g de frambuesas
60 g de azúcar
Zumo de un limón
4 bolas de sorbete de frambuesa
4 bolas de sorbete de limón
Salsa de vainilla preparada

Bata a punto de nieve las claras con el azúcar y una pizca de sal. Con ayuda de una manga pastelera haga 4 círculos de 10 cm de diámetro y 2 cm de altura sobre una bandeja de horno. Precaliente el horno a 50 °C. Introduzca la masa en el horno y hornee durante 5 horas. Bata la nata fresca con el azúcar en polvo. Haga puré las frambuesas junto con el azúcar y el zumo de limón y páselo después por el tamiz. Ponga una bola de sorbete de frambuesa y otra de sorbete de limón en cada círculo de merengue y con una manga pastelera ponga alrededor la mezcla de crema fresca hasta que el sorbete esté completamente tapado. Congele. Para servir saque el sorbete del congelador 5 minutos antes, haga un dibujo decorativo en los platos con la salsa de frambuesa y de vainilla y ponga al lado el postre. Espolvoree los bordes de los platos con cacao.

100 g di albume
200 g di zucchero
1 pizzico di sale
100 g di crème fleurette (crème fraîche liquida
con 35 % di grassi)
60 g di zucchero a velo
200 g di lamponi
60 g di zucchero
Succo di un limone
4 palline di sorbetto di lampone
4 palline di sorbetto di limone
Salsa di vaniglia pronta

Montate l'albume a neve con lo zucchero e un pizzico di sale. Servendovi di una sacca da pasticciere formate su una placca da forno 4 dischi di 10 cm di diametro e 2 cm di altezza. Preriscaldate il forno a 50 °C. Passate i dischi in forno e lasciateli asciugare per 5 ore. Montate la crème fleurette con lo zucchero a velo. Riducete in purea i lamponi con lo zucchero e il succo di limone e passateli in un colino. Mettete su ogni meringa una pallina di sorbetto di lampone e una di limone e, con una sacca da pasticciere, spremete intorno il composto di crème fleurette fino a coprire completamente il sorbetto. Mettete a congelare. 5 minuti prima di servire, togliete il dessert dallo scomparto del ghiaccio, create sul piatto un motivo decorativo con la salsa di lampone e di vaniglia e sistematevi vicino il dessert gelato. Spolverate il bordo del piatto con cacao.

Lô Sushi

Design: Andrée Putman | Chef: Quan | Owner: Laurent Taieb

8, Rue de Berri | 75008 Paris | 8e arrondissement
Phone: +33 1 45 62 01 00
www.losushi.com
Metro: Franklin D. Roosevelt
Opening hours: Mon–Sun noon to midnight
Average price: € 40
Cuisine: Asian

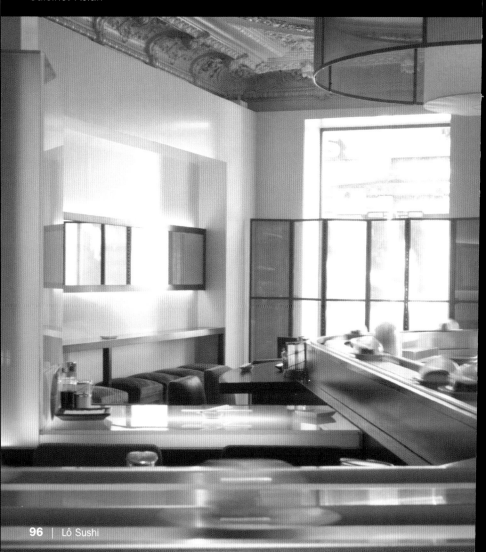

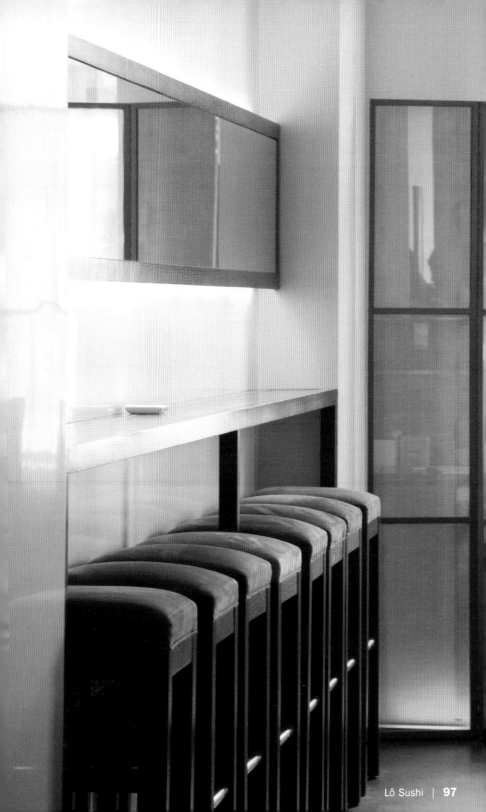

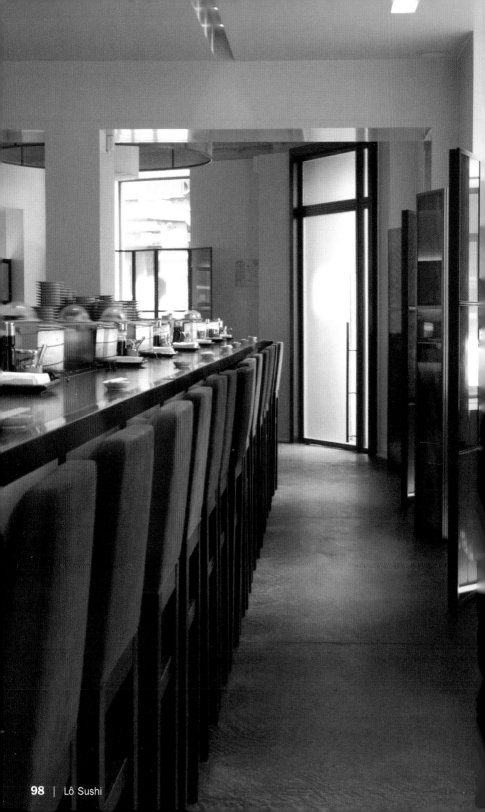

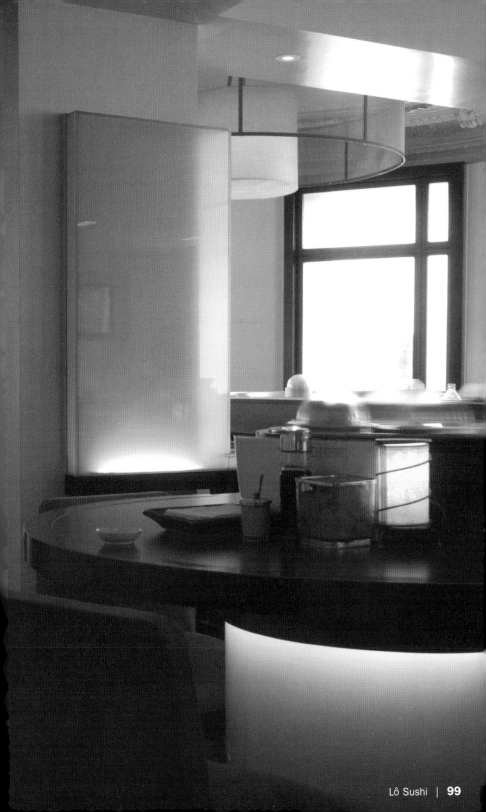

Maison Blanche

Design: Imaad Rahmouni | Chef: Jaques & Laurent Pourcel

15, Avenue Montaigne | 75008 Paris | 8e arrondissement
Phone: +33 1 47 23 55 99
www.maison-blanche.fr | info@maison-blanche.fr
Metro: Alma-Marceau, Franklin D. Roosevelt
Opening hours: Mon–Fri noon to 1:45 pm, Mon–Sat 8 pm to 10:30 pm
Average price: € 90
Cuisine: French
Special features: Terrace view of the Eiffel Tower

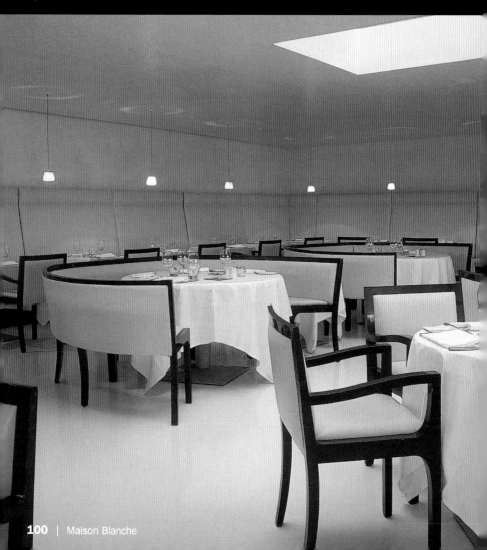

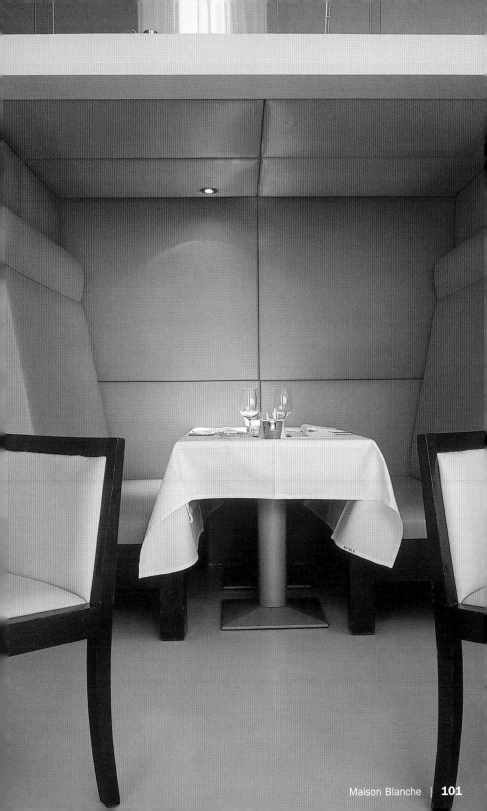

Foie de canard
poêlé au pamplemousse et poireau

Seared Duck Liver with Grapefruits and Leek

Gebratene Entenleber mit Pampelmusen
und Lauch

Hígado de pato asado con pomelos y puerro

Fegato di anatra in padella con pompelmi
e porri

4 foies de canard de 80 g chacun
3 c. à soupe de beurre
2 pamplemousses roses pelés à vif
40 g de sucre glace
2 poireaux en rondelles
500 ml de banyuls réduit en sirop
Jus d'un demi citron
3 c. à soupe d'huile d'olive
Sel, poivre
Feuilles de coriandre pour la décoration
Pain d'épices

Peler fin les zestes de pamplemousse et les couper en fines lamelles. Les blanchir deux fois puis les faire confire avec le sucre dans un peu d'eau pendant environ une demie heure. Mettre au frais. Blanchir les rondelles de poireau à l'eau bouillante salée, saisir à l'eau froide et égoutter. Mélanger le sirop de banyuls avec le jus du demi citron, le jus d'un pamplemousse et l'huile d'olive et assaisonner. Disposer les quartiers de pample-mousse et le poireau dans des assiettes creuses, réchauffer légèrement les assiettes. Faire revenir les foies de canard dans un peu de beurre, saler, poivrer et réserver au chaud. Arroser la salade avec la vinaigrette de banyuls et déposer les foies de canard dessus. Garnir avec les feuilles de coriandre et les zestes de pamplemousse. Servir avec du pain d'épices.

4 duck livers, 2 ½ oz each
3 tbsp butter
2 pink grapefruits, fillets only
1 ½ oz powdered sugar
2 leeks, cut in rings
500 ml Banyuls, reduced to syrup
Juice of ½ lemon
3 tbsp olive oil
Salt, pepper
Cilantro leaves for decoration
Spice bread

Peel the grapefruit skin in very thin slices and cut in fine stripes. Blanch twice, then bring to a boil with little water and sugar and cook for half an hour. Chill. Blanch the leek rings in salted water, chill and drain. Combine the Banyuls syrup with the lemon juice, the grapefruit juice and olive oil and season for taste. Arrange the grapefruit fillets and the leek in deep plates and warm the plates. Sear the duck livers in some butter, season with salt and pepper and keep warm. Drizzle the Banyuls vinaigrette over the plates and place the duck liver on top of the salad. Garnish with cilantro leaves and grapefruit peel and serve with spice bread.

4 Entenlebern à 80 g
3 EL Butter
2 rosa Pampelmusen, filetiert
40 g Puderzucker
2 Stangen Lauch, in Ringen
500 ml Banyuls, zu Sirup reduziert
Saft einer ½ Zitrone
3 EL Olivenöl
Salz, Pfeffer
Korianderblätter zur Dekoration
Gewürzbrot

Die Pampelmusenschale hauchdünn abschälen und in feine Streifen schneiden. Zweimal blanchieren, dann zusammen mit dem Zucker in etwas Wasser ungefähr eine halbe Stunde einkochen. Kühl stellen. Die Lauchringe in sprudelndem Salzwasser blanchieren, abschrecken und abtropfen lassen. Den Banyuls-Sirup mit dem Saft der halben Zitrone, dem Saft der Pampelmuse und dem Olivenöl mischen und abschmecken. Die Pampelmusenspalten und den Lauch auf tiefen Tellern anrichten, die Teller leicht anwärmen. Die Entenleber in etwas Butter anbraten, mit Salz und Pfeffer würzen und warm stellen. Die Banyuls-Vinaigrette über die Teller träufeln und die Entenleber auf den Salat setzen. Mit Korianderblättern und Pampelmusenschale garnieren und mit Gewürzbrot servieren.

4 hígados de pato de 80 g cada uno
3 cucharadas de mantequilla
2 pomelos rosas, en lonchas
40 g de azúcar en polvo
2 tallos de puerro, en aros
500 ml de Banyuls, reducido a sirope
El zumo de medio limón
3 cucharadas de aceite de oliva
Sal, pimienta
Hojas de cilantro para decorar
Pan de especias

Pele finamente los pomelos y córtelos en tiras. Escáldelos dos veces y cuézalos en un poco de agua con el azúcar durante aproximadamente media hora. Póngalos después a enfriar. Escalde los aros de puerro en agua hirviendo, póngalos después debajo de un chorro de agua helada y escúrralos. Mezcle el sirope de Banyuls con el zumo de medio limón, el zumo de los pomelos y el aceite de oliva y sazone al gusto. Reparta las tiras de pomelo y los aros de puerro en cuatro platos hondos y caliente ligeramente los platos. Fría los hígados de pato en un poco de mantequilla, salpimiente y resérvelos fríos. Vierta la vinagreta por encima de los ingredientes de los platos y coloque los hígados encima de la lechuga. Adorne con hojas de cilantro y con la piel de pomelo y sirva con pan de especias.

4 fegati di anatra da 80 g l'uno
3 cucchiai di burro
2 pompelmi rosa filettati
40 g di zucchero a velo
2 gambi di porro a rondelle
500 ml di Banyuls ridotto a sciroppo
Succo di ½ limone
3 cucchiai di olio d'oliva
Sale, pepe
Foglie di coriandolo per decorare
Pan di spezie

Togliete la scorza dei pompelmi asportandone uno strato sottilissimo, che taglierete poi a listarelle sottili. Sbollentate la scorza due volte, fatela quindi candire con lo zucchero in un po' d'acqua per una mezz'ora circa. Mettete al fresco. Sbollentate le rondelle di porro in acqua salata bollente, raffreddatele con acqua fredda e fatele sgocciolare. Mescolate lo sciroppo Banyuls al succo del limone e dei pompelmi, all'olio d'oliva e correggete di sapore. Disponete gli spicchi di pompelmo e il porro su piatti fondi e intiepidite i piatti. Fate rosolare i fegati di anatra in un po' di burro, salateli e pepateli e metteteli in caldo. Versate sui piatti alcune gocce di vinaigrette al Banyuls e disponete i fegati di anatra sull'insalata. Guarnite con foglie di coriandolo e scorza di pompelmo e servite con pan di spezie.

Mandala Ray

Design: Miguel Cancia Martins | Chefs: Marc Marchand,
Jérémie Normand, Ming | Owner: Thierry Klemeniuk

32–34, Rue Marbeuf | 75008 Paris | 8e arrondissement
Phone: +33 1 56 88 36 36
www.manray.fr | contact@mandalaray.com
Metro: Franklin D. Roosevelt, Alma-Marceau
Opening hours: Sun–Thu 7 pm to 2 am, Fri–Sat 7 pm to 5 am
Average price: € 60
Cuisine: French, Asian
Special features: Every Monday "Monday's Opéra", club Friday and Saturday

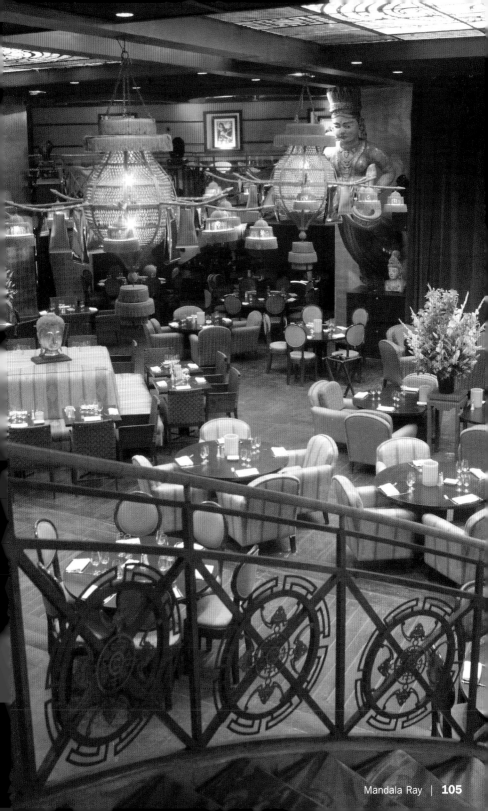

Crème d'avocat
au crabe royal et concassée de tomate

Avocado Cream with Tomato-King Crab-Salsa

Avocadocreme mit Tomaten-Königskrabben-salsa

Crema de aguacate con salsa de cangrejos reales y tomate

Crema di avocado con dadolata di pomodori e di granchio reale

4 tomates pelées, épépinées, en dés
120 g de chair de crabe royal en dés
1 c. à café de vinaigre de vin blanc
Sel, poivre, sucre

2 avocats pelés dénoyautés
1 c. à café de jus de citron
1 goutte de tabasco
50 ml de crème fouettée
Sel, poivre

Lamelles de poivron rouge, feuilles de salade et vinaigre balsamique pour la décoration

Mélanger les tomates en dés avec la chair de crabe et assaisonner avec le sel, le poivre, le sucre et le vinaigre. Réduire les avocats en purée avec le jus de citron et le tabasco, saler, poivrer et incorporer la crème fouettée. Fermer quatre bandes métalliques en forme de goutte, remplir le fond avec 1,5 cm de concassée de tomate au crabe et recouvrir de crème d'avocat. Mettre au frais. Pour démouler, passer un couteau chaud à l'intérieur du moule. Garnir de lamelles de poivron, de feuilles de salade et de vinaigre balsamique.

4 tomatoes, peeled, seeded, diced
4 oz king crab meat, diced
1 tsp white wine vinegar
Salt, pepper, sugar

2 avocados, peeled, seeded
1 tsp lemon juice
Splash tabasco
50 ml cream, beaten
Salt, pepper

Red bell pepper strips, lettuce and balsamic vinegar for decoration

Mix diced tomatoes with the king crab meat and season with salt, pepper, sugar and vinegar. Mash avocados, stir in lemon juice and tabasco, season with salt and pepper and fold under the whipped cream. Bend four metal bands into a tear shape, fill in the tomato-king crab-salsa to approx. ½ inch high and cover with avocado cream. Chill. Loosen the metal bands with a hot knife and garnish with bell pepper strips, lettuce and balsamic vinegar.

4 Tomaten, geschält, entkernt, gewürfelt
120 g Königskrabbenfleisch, gewürfelt
1 TL Weißweinessig
Salz, Pfeffer, Zucker

2 Avocados, geschält, entkernt
1 TL Zitronensaft
Spritzer Tabasco
50 ml Sahne, geschlagen
Salz, Pfeffer

Rote Paprikastreifen, Salatblätter und Balsamico-
essig zur Dekoration

Tomatenwürfel mit Königskrabbenfleisch mischen und mit Salz, Pfeffer, Zucker und Essig abschmecken. Avocados pürieren, Zitronensaft und Tabasco unterrühren, mit Salz und Pfeffer abschmecken und die geschlagene Sahne unterheben. Vier Metallbänder in eine Tränenform biegen, die Tomaten-Königskrabbensalsa ca. 1,5 cm hoch einfüllen und mit der Avocadocreme bedecken. Kaltstellen. Die Formen mit einem heißen Messer lösen und mit Paprikastreifen, Salatblättern und Balsamicoessig garnieren.

4 tomates, pelados, despepitados y en dados
120 g de carne de cangrejos reales, en dados
1 cucharadita de vinagre de vino blanco
Sal, pimienta, azúcar

2 aguacates, pelados y sin hueso
1 cucharadita de zumo de limón
1 chorrito de tabasco
50 ml de nata, batida
Sal, pimienta

Tiras de pimiento rojo, hojas de lechuga y vinagre balsámico para decorar

Mezcle los dados de tomate con la carne de cangrejo y sazone con sal, pimienta, azúcar y vinagre. Haga puré los aguacates, añada el zumo de limón y el tabasco y remueva, salpimiente, incorporare la nata batida y mézclela con los demás ingredientes. Dé forma de lágrima a cuatro tiras de metal, rellene con la salsa de tomate y cangrejo hasta una altura de aprox. 1,5 cm cúbrala con la crema de aguacate. Reserve en un lugar frío. Separe los moldes con un cuchillo caliente y decore con las tiras de pimiento, hojas de lechuga y vinagre balsámico.

4 pomodori pelati, privati dei semi e tagliati a dadini
120 g di polpa di granchio reale tagliata a dadini
1 cucchiaino di aceto di vino bianco
Sale, pepe, zucchero

2 avocado mondati e privati dei semi
1 cucchiaino di succo di limone
Spruzzo di tabasco
50 ml di panna montata
Sale, pepe

Strisce di peperone rosso, foglie d'insalata e aceto balsamico per decorare

Mescolate i dadini di pomodoro alla polpa di granchio reale, correggete di sale, pepe, zucchero e aceto. Riducete gli avocado in purea, incorporatevi il succo di limone e il tabasco, correggete di sale e pepe e aggiungetevi delicatamente la panna montata. Piegate a forma di lacrima quattro nastri metallici, riempiteli con uno strato di ca. 1,5 cm di dadolata di pomodori e di granchio reale e ricopriteli con crema di avocado. Mettete a raffreddare. Staccate gli stampini con un coltello molto caldo e guarnite con strisce di peperone, foglie d'insalata e aceto balsamico.

Market

Design: Christian Liaigre | Chef: Wim van Gorp
Owner: Jean-Georges Vongerichten
15, Avenue Matignon | 75008 Paris | 8e arrondissement
Phone: +33 1 56 43 40 90
www.jean-georges.com | prmarketsa@aol.com
Metro: Franklin D. Roosevelt
Opening hours: Mon–Fri breakfast 8 am to 11 am, Mon–Sun lunch noon to 3 pm,
dinner 7 pm to 11:30 pm, brunch Sat–Sun noon to 6 pm
Average price: € 27
Cuisine: World food
Special features: Bar lounge

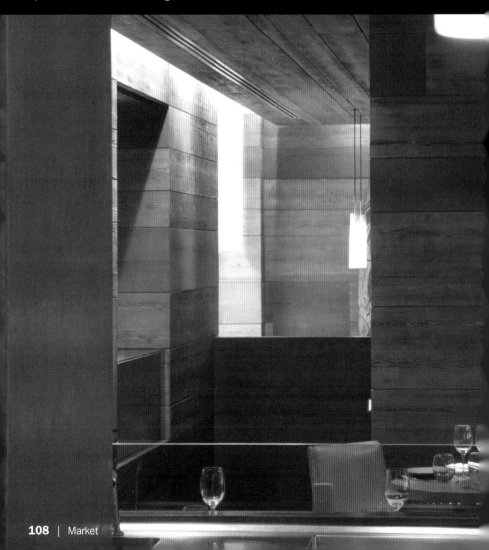

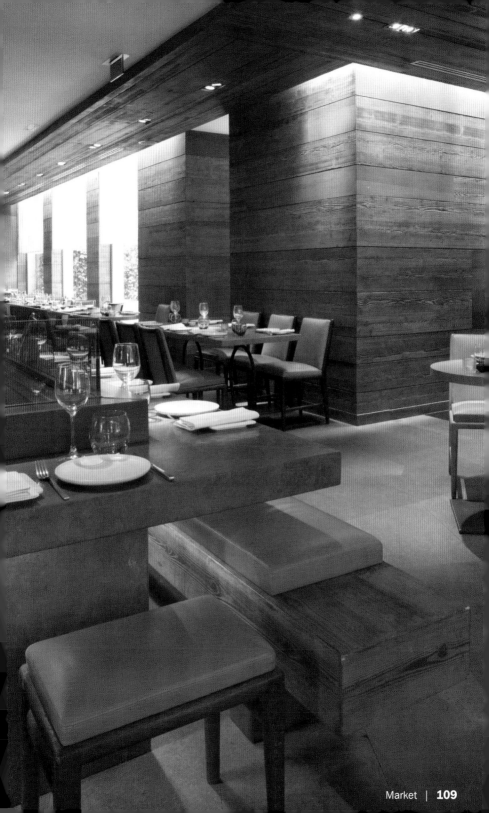

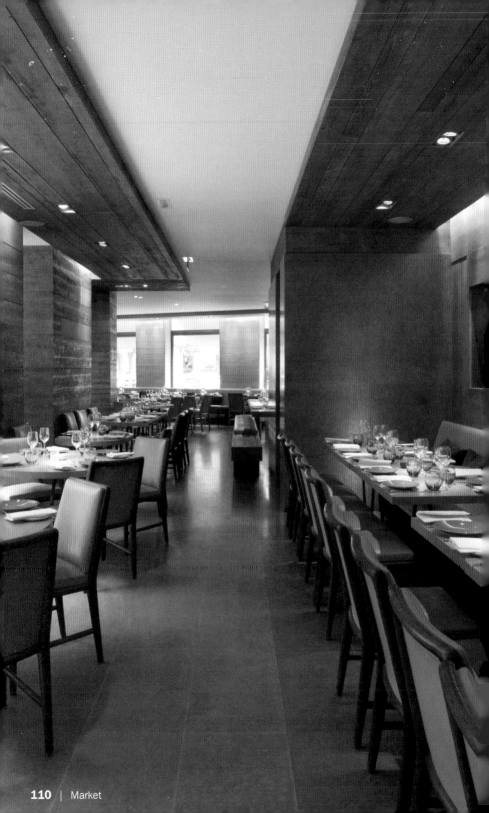

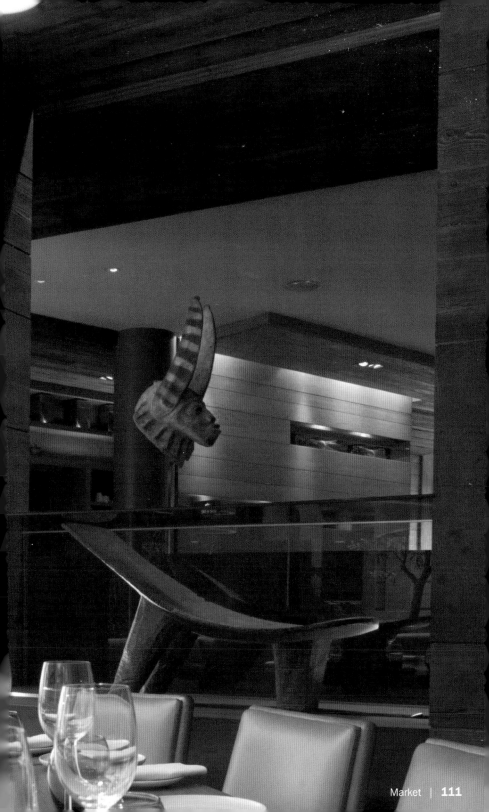

Murano

Design: Raymond Morel | Chef: Julien Chicoisne & Pierre Augé
Head Sommelier: Miloud Azzaoui

13, Boulevard du Temple | 75003 Paris | 3e arrondissement
Phone: +33 1 42 71 20 00
www.muranoresort.com | paris@muranoresort.com
Metro: Filles du Calvaire
Opening hours: Every day noon to 4 pm, 8 pm to midnight
Average price: € 55
Cuisine: Mediterranean, contemporary
Special features: Vegetarian cuisine, open terrace

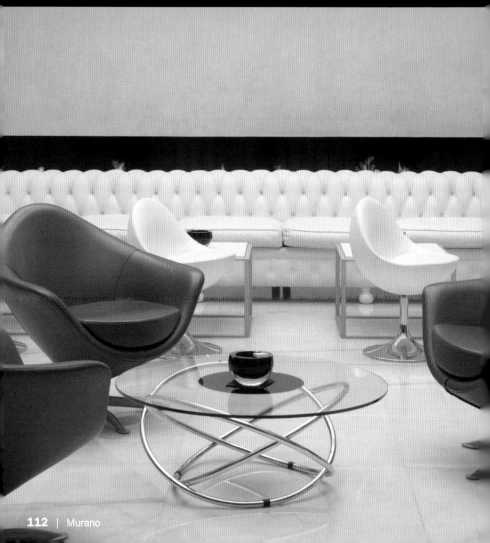

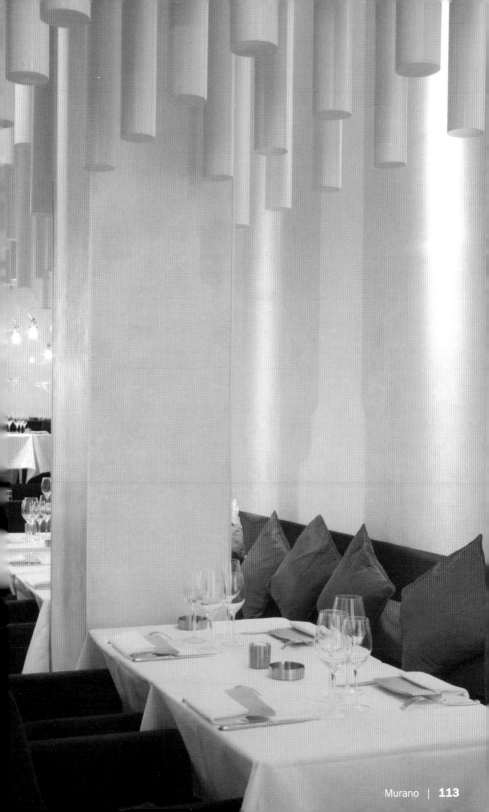

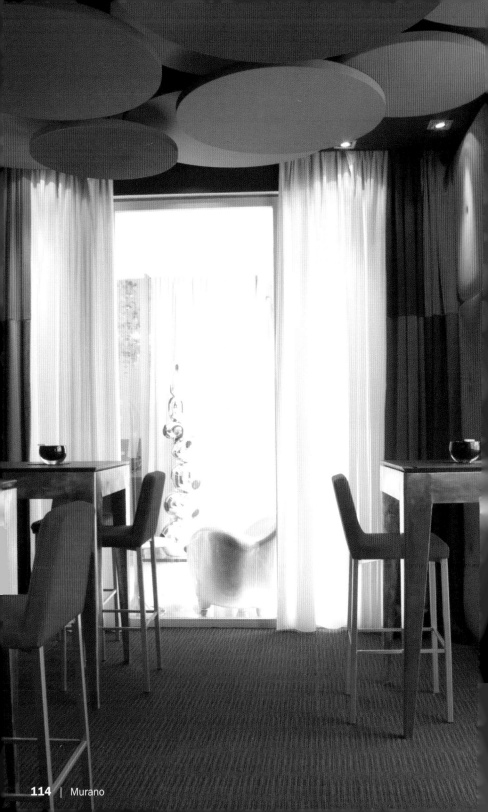

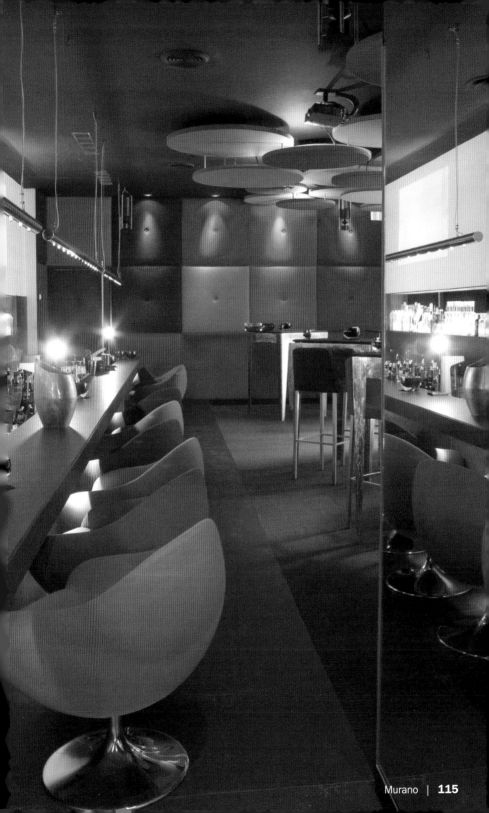

Daurade
et sa purée de carottes

Gilthead Seabream with carrot puree
Goldbrasse mit Karottenpüree
Dorada con puré de zanahoria
Orata con purea di carote

4 filets de daurade de 180 g chacun
4 carottes épluchées en dés
120 ml de bouillon de légumes
2 c. à soupe d'huile d'olive
2 pommes vertes en bâtonnets avec la peau
1 c. à soupe de jus de citron
2 c. à soupe de beurre
Sel, poivre

Faire cuire les dés de carottes dans le bouillon de légumes, réduire en purée, saler, poivrer, ajouter une noisette de beurre et garder au chaud. Arroser les bâtonnets de pomme de jus de citron. Assaisonner les filets de daurade et les faire dorer dans l'huile d'olive env. 3 minutes de chaque côté. Pour servir, disposer une quenelle de purée de carottes, les bâtonnets de pomme citronnés et un filet de daurade sur chacune des quatre assiettes.

4 gilthead seabream fillets, 6 oz each
4 carrots, peeled and diced
120 ml vegetable stock
2 tbsp olive oil
2 green apples, cut in thin sticks with skin
1 tbsp lemon juice
2 tbsp butter
Salt, pepper

Cook the diced carrots in vegetable stock until soft, mash, season with butter, salt and pepper and keep warm. Marinade the apple sticks with lemon juice. Season the gilthead seabream fillet and sear for approx. 3 minutes in olive oil from each side. To serve, put one scoop of carrot puree on each plate, place the marinated apple sticks beside it and lean one gilthead seabream fillet against it.

4 Goldbrassenfilets, à 180 g
4 Karotten, geschält und gewürfelt
120 ml Gemüsebrühe
2 EL Olivenöl
2 grüne Äpfel, mit Schale in dünne Stifte geschnitten
1 EL Zitronensaft
2 EL Butter
Salz, Pfeffer

Karottenwürfel in der Gemüsebrühe weich kochen, pürieren, mit Butter, Salz und Pfeffer abschmecken und warm stellen. Die Apfelstreifen mit Zitronensaft marinieren. Die Goldbrassenfilets würzen und in Olivenöl von jeder Seite ca. 3 Minuten anbraten. Zum Servieren je eine Nocke Karottenpüree auf vier Teller geben, die marinierten Apfelstifte daneben setzen und das Goldbrassenfilet anlegen.

4 filetes de dorada, de 180 g cada uno
4 zanahorias, peladas y en dados
120 ml de caldo de verdura
2 cucharadas de aceite de oliva
2 manzanas verdes, con piel y cortadas en delgadas tiras
1 cucharada de zumo de limón
2 cucharadas de mantequilla
Sal, pimienta

Cueza los dados de zanahoria en el caldo de verdura hasta que estén tiernos, hágalos puré, sazone con mantequilla, sal y pimienta y reserve caliente. Marine las tiras de manzana con el zumo de limón. Sazone los filetes de dorada y fríalos en aceite durante aprox. 3 minutos por cada lado. Para servir ponga en los platos un poco del puré de zanahoria, las tiras marinadas de manzana y, al lado, el pescado.

4 filetti di orata da 180 g l'uno
4 carote mondate e tagliate a dadini
120 ml di brodo vegetale
2 cucchiai di olio d'oliva
2 mele verdi con buccia, tagliate a bastoncini
1 cucchiaio di succo di limone
2 cucchiai di burro
Sale, pepe

Lessate bene i dadini di carote nel brodo vegetale, riducete in purea, insaporite con il burro, correggete di sale e pepe, e mettete in caldo. Marinate i bastoncini di mela con il succo di limone. Condite i filetti di orata e rosolateli in olio d'oliva per ca. 3 minuti per lato. Prima di servire, mettete su quattro piatti una grossa noce di purea di carote, sistematevi vicino i bastoncini di mele e accanto il filetto di orata.

The
Cristal Room Baccarat

Design: Philippe Starck | Chef: Thierry Burlot

11, Place des Etats-Unis | 75016 Paris | 16e arrondissement
Phone: +33 1 40 22 11 10
www.baccarat.fr | cristalroom@baccarat.fr
Metro: Boissière
Opening hours: Mon–Sun 8:30 am to 10:30 am, noon to 2:30 pm, 8 pm to 10:30 pm
Average price: € 50
Cuisine: French, contemporary

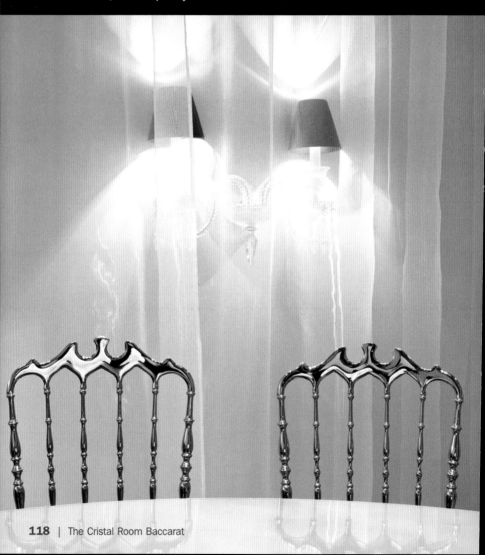

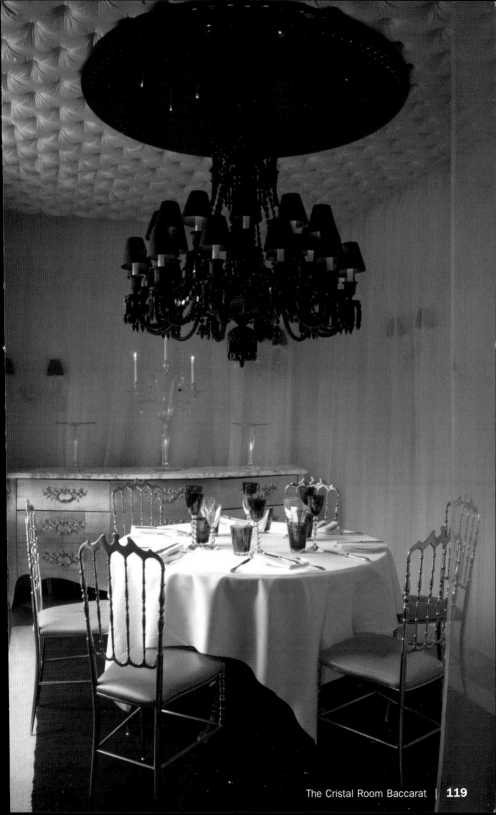

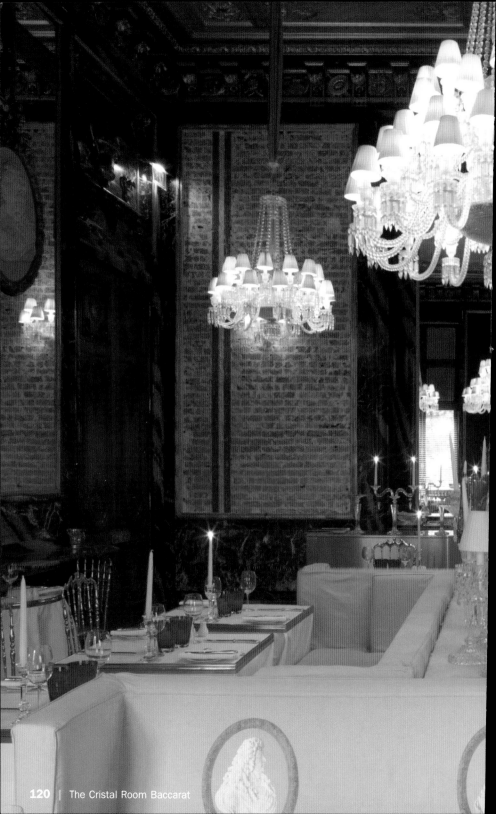

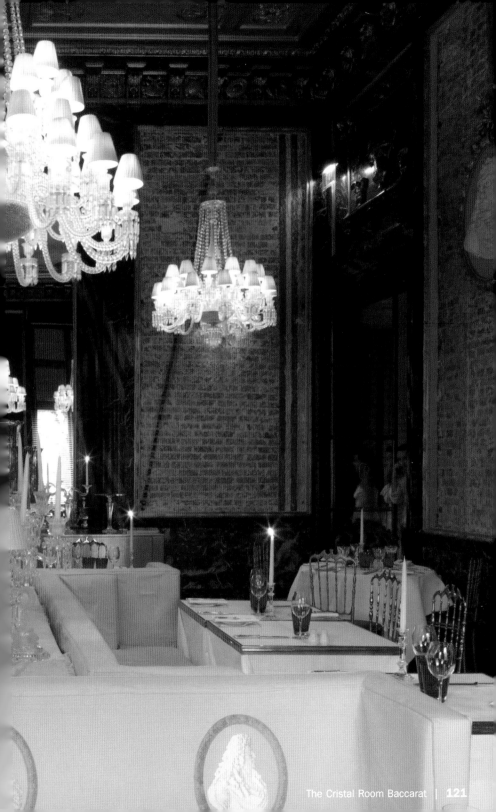

Homard rôti
aux cèpes et au potiron

Fried Lobster with Edible Boletus and Pumpkin

Gebratener Hummer mit Steinpilzen und Kürbis

Langosta asada con boletos y calabaza

Astice in padella con porcini e zucca

2 homards de 600 g crus
1 petit potiron doux d'Hokkaido
6 cèpes de taille moyenne
150 ml de crème
½ gousse de vanille
2 c. à soupe d'huile d'olive
5 c. à soupe de beurre
Sel, poivre

Peler le potiron d'Hokkaido et le couper en tranches. Le cuire à l'eau bouillante jusqu'à ce qu'il soit tendre, égoutter et réserver. Nettoyer les cèpes, les couper en deux et les faire colorer sur la tranche dans de l'huile d'olive. Détacher les queues et les pinces des homards et les faire revenir dans 3 c. à soupe de beurre chaud env. 4 minutes des deux côtés. Retirer les morceaux de homard du beurre et déglacer le fond avec la crème, assaisonner avec sel, poivre et un peu de pulpe de vanille. Faire revenir les tranches de potiron dans 2 c. à soupe de beurre, saler et poivrer. Passer la sauce au chinois et la faire mousser. Pour servir, couper chaque queue de homard en 4 morceaux et disposer sur une assiette 2 morceaux de queue avec une pince, trois demi-cèpes et une tranche de potiron. Arroser de sauce.

2 lobster, 20 oz each, raw
1 small Hokkaido pumpkin
6 medium edible boletus
150 ml cream
½ vanilla beam
2 tbsp olive oil
5 tbsp butter
Salt, pepper

Peel the Hokkaido pumpkin and cut in wedges. Boil in salted water until tender, drain and set aside. Clean the edible boletus, half and sear on the cut side in olive oil. Remove the tails and claws of the lobster and sear in 3 tbsp hot butter from both sides for approx. 4 minutes. Take the lobster parts out off the butter and quench the drippings with cream, season with salt, pepper and some vanilla. Sear the pumpkin wedges in 2 tbsp butter, season with salt and pepper. Pour the sauce through a sieve and beat to froth. To serve, cut each lobster tail in 4 pieces and arrange 2 pieces tail, one claw, three halved edible boletus and one pumpkin wedge on each plate. Drizzle with sauce.

2 Hummer, à 600 g, roh
1 kleiner Hokkaido-Kürbis
6 mittelgroße Steinpilze
150 ml Sahne
½ Vanilleschote
2 EL Olivenöl
5 EL Butter
Salz, Pfeffer

Den Hokkaido-Kürbis schälen und in Spalten schneiden. In kochendem Salzwasser weich garen, abtropfen lassen und beiseite stellen. Die Steinpilze putzen, halbieren und auf der Schnittfläche in Olivenöl scharf anbraten. Die Schwänze und Scheren der Hummer abtrennen und in 3 EL heißer Butter ca. 4 Minuten von beiden Seiten anbraten. Die Hummerteile aus der Butter nehmen und den Satz mit Sahne ablöschen, mit Salz, Pfeffer und etwas Vanillemark abschmecken. Die Kürbisspalten in 2 EL Butter anbraten, mit Salz und Pfeffer würzen. Die Sauce durch ein Sieb gießen und aufschäumen. Zum Servieren die Hummerschwänze in jeweils 4 Teile schneiden und je 2 Teile Schwanz mit einer Schere, drei halben Steinpilzen und einer Kürbisspalte auf dem Teller anrichten. Mit Sauce beträufeln.

2 langostas, de 600 g cada una, crudas
1 calabaza Hokkaido pequeña
6 boletos medianos
150 ml de nata
½ vaina de vainilla
2 cucharadas de aceite de oliva
5 cucharadas de mantequilla
Sal, pimienta

Pele la calabaza Hokkaido y córtela en rodajas. Cuézala en agua hirviendo con sal hasta que esté blanda, escúrrala y reserve. Limpie los boletos, córtelos en mitades y fríalos bien por el lado del corte en una sartén con aceite de oliva. Separe las colas y las pinzas y fríalas en 3 cucharadas de mantequilla caliente durante aprox. 4 minutos por ambos lados. Retire las partes de la langosta de la mantequilla. Vierta la nata en la sartén y condimente con la sal, la pimienta y unas cuantas semillas de la vaina de vainilla. Sofría las rodajas de calabaza en 2 cucharadas de mantequilla y salpimiente. Pase la salsa por un colador y bata hasta obtener espuma. Para servir corte las colas en 4 trozos y ponga 2 en cada plato junto con una pinta, tres mitades de boleto y una rodaja de calabaza. Vierta por encima la salsa.

2 astici crudi da 600 g l'uno
1 zucca hokkaido piccola
6 funghi porcini medi
150 ml di panna
½ stecca di vaniglia
2 cucchiai di olio d'oliva
5 cucchiai di burro
Sale, pepe

Pelate la zucca hokkaido e tagliatela a spicchi. Lessatela bene in acqua salata bollente, fatela sgocciolare e mettetela da parte. Mondate i porcini, tagliateli a metà e fateli rosolare bene nell'olio d'oliva sulla superficie tagliata. Separate le code e le chele degli astici e fatele rosolare in 3 cucchiai di burro bollente per ca. 4 minuti da entrambi i lati. Togliete i pezzi di astice dal burro e bagnate il fondo di cottura con la panna, correggete di sale e pepe e insaporite con un po' di vaniglia pura. Fate rosolare gli spicchi di zucca in 2 cucchiai di burro, salate e pepate. Passate la salsa in un colino e montatela a spuma. Prima di servire, tagliate ciascuna coda di astice in 4 parti. Disponete quindi su ogni piatto 2 pezzi di coda con una chela, tre metà di porcini e uno spicchio di zucca, e versatevi alcune gocce di salsa.

Tokyo Eat Palais de Tokyo
Site de création contemporaine

Design: Stéphane Maupin | Chef: Thierry Bassard
Owners: Claudio Episcopo, Eric Wapler

13, Avenue du Président-Wilson | 75016 Paris | 16e arrondissement
Phone: +33 1 47 200 00 29
www.palaisdetokyo.com
Metro: Iéna, Alma-Marceau
Opening hours: Tue–Sun noon to 3 pm, 8 pm to 11:30 pm
Average price: € 25
Cuisine: French, contemporary

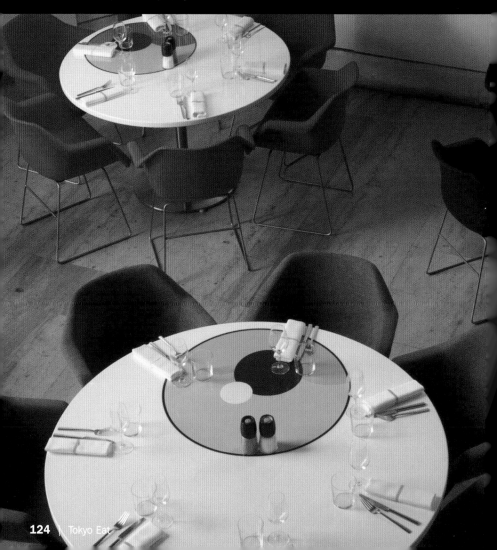

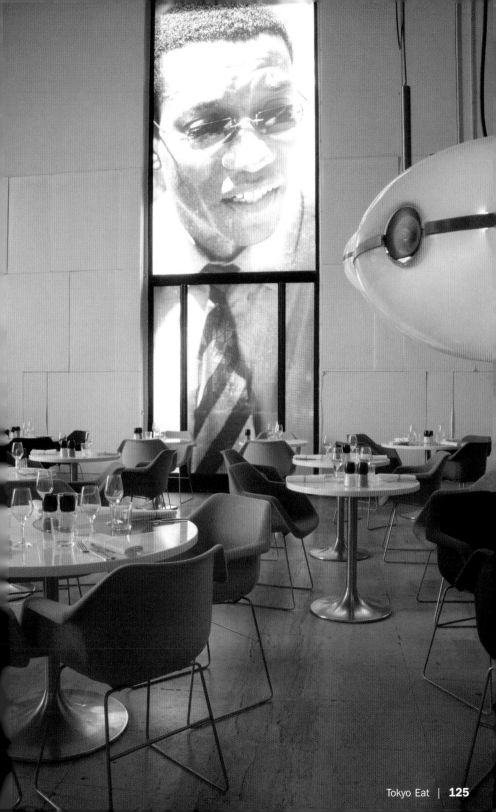

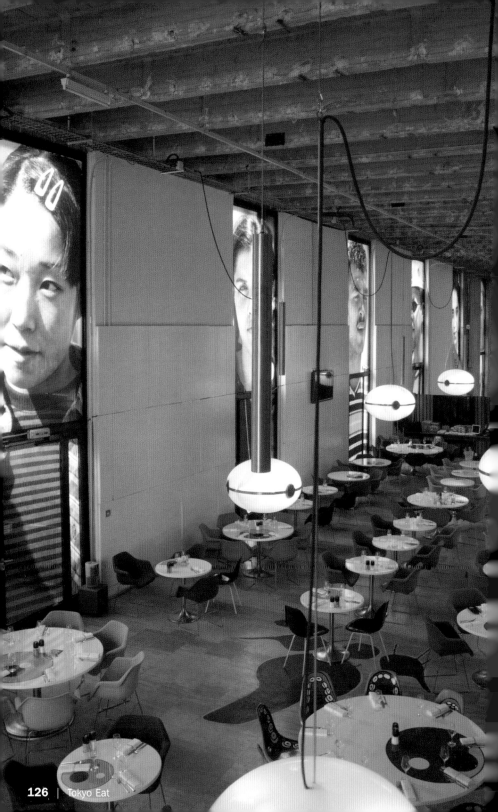

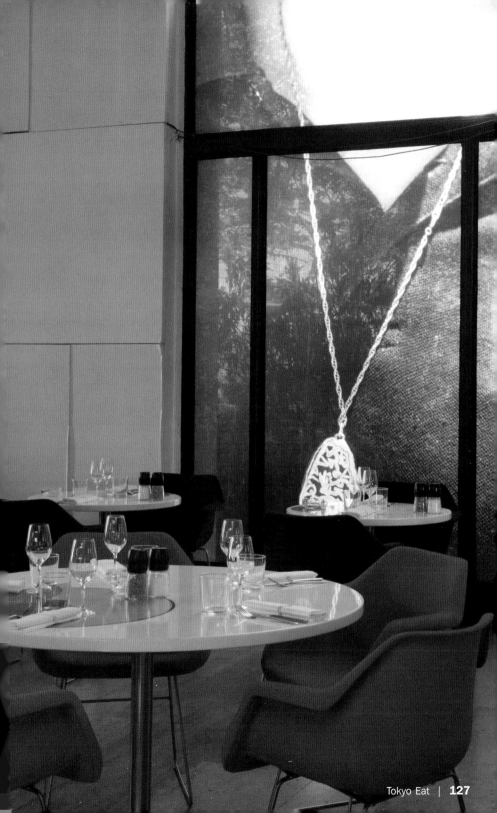

Daurade

à la sauce cacahuète et aubergine

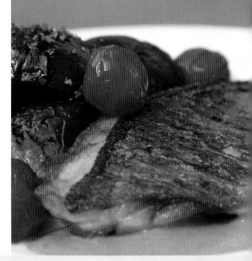

Gilthead Seabream in Peanut Sauce with Eggplants

Goldbrasse in Erdnusssauce mit Auberginen

Dorada en salsa de cacahuete con berenjenas

Orata in salsa di arachidi con melanzane

4 filets de daurade de 180 g
2 aubergines en tranches de 1,5 cm d'épaisseur
12 tomates cerises
1 c. à soupe de pâte de curry rouge
1 c. à café de curcuma
2 c. à soupe de lait de coco
2 c. à soupe d'eau
180 g de sucre glace
200 g de beurre de cacahuète non sucré
1 c. à café de « fish sauce »
2 c. à soupe de jus de citron
2 gousses d'ail hachées
1 c. à soupe de gingembre haché
1 c. à soupe de sauce Shao-Xing
3 c. à soupe de sauce chili
1 c. à soupe de sauce soja
2 c. à soupe de vinaigre de riz
2 c. à soupe d'huile d'olive

Faire rôtir les tranches d'aubergine au four à 160 °C pendant 20 minutes. Après 10 minutes, leur ajouter les tomates cerises. Faire revenir la pâte de curry rouge et le curcuma dans l'huile d'olive, mouiller avec le lait de coco et l'eau et incorporer le sucre glace et le beurre de cacahuètes. Laisser réduire 10 minutes et rectifier l'assaisonnement avec la fish sauce et le jus de citron. Garder au chaud. Dans une casserole, mélanger et réchauffer l'ail, le gingembre, la sauce Shao-Xing, la sauce chili, la sauce de soja et le vinaigre de riz et verser sur les tranches d'aubergines. Assaisonner les filets de daurade et les faire dorer dans l'huile d'olive 3 minutes de chaque côté. Dresser les filets sur les assiettes, répartir tout autour les tranches d'aubergines et les tomates cerises et napper de sauce.

4 gilthead seabream fillets, 6 oz each
2 eggplants, in ½ inch slices
12 cherry tomatoes
1 tbsp red curry paste
1 tsp curcuma
2 tbsp coconutmilk
2 tbsp water
6 oz powdered sugar
6 ½ oz unsweetened peanut butter
1 tsp fish sauce
2 tbsp lemon juice
2 cloves of garlic, chopped
1 tbsp ginger, chopped
1 tbsp Shao-Xing sauce
3 tbsp chili sauce
1 tbsp soy sauce
2 tbsp rice vinegar
2 tbsp olive oil

Bake the eggplant slices in a 320 °F oven for 20 minutes. After 10 minutes add the tomatoes to the eggplants. Saute the red curry paste and the curcuma in olive oil, fill up with coconutmilk and water and stir in the powdered sugar and the peanut butter. Reduce for 10 minutes, season with fish sauce and lemon juice. Keep warm. Combine garlic, ginger, Shao-Xing sauce, chili sauce, soy sauce and rice vinegar in a small pot, heat and pour over the eggplant slices. Season the gilthead seabream fillets and sear in olive oil on both sides for 3 minutes. Arrange gilthead seabream fillets on plates, spread the eggplant slices and the cherry tomatoes around it and drizzle with sauce.

4 Goldbrassenfilets, à 180 g
2 Auberginen, in 1,5 cm dicken Scheiben
12 Kirschtomaten
1 EL rote Currypaste
1 TL Kurkuma
2 EL Kokosmilch
2 EL Wasser
180 g Puderzucker
200 g ungesüßte Erdnussbutter
1 TL Fischsauce
2 EL Zitronensaft
2 Knoblauchzehen, gehackt
1 EL Ingwer, gehackt
1 EL Shao-Xing Sauce
3 EL Chilisauce
1 EL Sojasauce
2 EL Reisessig
2 EL Olivenöl

Die Auberginenscheiben im Backofen bei 160 °C 20 Minuten backen. Nach 10 Minuten die Kirschtomaten zu den Auberginen geben. Die rote Currypaste und das Kurkuma in Olivenöl anbraten, mit Kokosmilch und Wasser ablöschen und den Puderzucker und die Erdnussbutter unterrühren. 10 Minuten einkochen lassen, dann mit Fischsauce und Zitronensaft abschmecken. Warmhalten. In einem kleinen Topf Knoblauch, Ingwer, Shao-Xing Sauce, Chilisauce, Sojasauce und Reisessig mischen, erhitzen und über die Auberginenscheiben gießen. Die Goldbrassenfilets würzen und in Olivenöl von jeder Seite 3 Minuten anbraten. Goldbrassenfilets auf Tellern anrichten, die Auberginenscheiben und Kirschtomaten darum verteilen und mit der Sauce beträufeln.

4 filetes de dorada, en tiras de 1,5 cm de grosor
2 berenjenas, en rodajas de 1,5 cm de grosor
12 tomates cereza
1 cucharada de pasta de curry roja
1 cucharadita de cúrcuma
2 cucharadas de leche de coco
2 cucharadas de agua
180 g de azúcar en polvo
200 g de mantequilla de cacahuete sin endulzar
1 cucharadita de salsa de pescado
2 cucharadas de zumo de limón
2 dientes de ajo, picados
1 cucharada de jengibre, picado
1 cucharada de salsa Shao-Xing
3 cucharadas de salsa de guindilla
1 cucharada de salsa de soja
2 cucharadas de vinagre de arroz
2 cucharadas de aceite de oliva

Ase las rodajas de berenjena en el horno a 160 °C durante 20 minutos. Al cabo de 10 minutos introduzca los tomates cereza. Sofría la pasta de curry y la cúrcuma en aceite de oliva, vierta después la leche de coco y el agua, incorpore el azúcar en polvo y la mantequilla de cacahuete y remueva. Deje que la mezcla cueza durante 10 minutos y sazone después con la salsa de pescado y el zumo de limón. Resérvela caliente. En una pequeña cazuela mezcle el ajo, el jengibre, la salsa Shao-Xing, la salsa de guindilla, la salsa de soja y el vinagre de arroz. Caliente los ingredientes y vierta la salsa por encima de las rodajas de berenjena. Sazone los filetes de dorada y fríalos en aceite de oliva durante 3 minutos por cada lado. Ponga los filetes en los platos, reparta alrededor del pescado las rodajas de berenjena y los tomates cereza y vierta por encima la salsa.

4 filetti di orata da 180 g l'uno
2 melanzane a fette di 1,5 cm di spessore
12 pomodorini ciliegia
1 cucchiaio di pasta di curry rossa
1 cucchiaino di curcuma
2 cucchiai di latte di cocco
2 cucchiai di acqua
180 g di zucchero a velo
200 g di burro di arachidi non dolcificato
1 cucchiaino di salsa di pesce
2 cucchiai di succo di limone
2 spicchi d'aglio tritati
1 cucchiaio di zenzero tritato
1 cucchiaio di salsa Shao Xing
3 cucchiai di salsa chili
1 cucchiaio di salsa di soia
2 cucchiai di aceto di riso
2 cucchiai di olio d'oliva

Fate cuocere le fette di melanzane in forno caldo a 160 °C per 20 minuti. Dopo 10 minuti aggiungetevi i pomodorini ciliegia. Fate soffriggere la pasta di curry rossa e la curcuma in olio d'oliva, bagnate con il latte di cocco e l'acqua e incorporatevi lo zucchero a velo e il burro di arachidi. Lasciate ridurre per 10 minuti, insaporite quindi con salsa di pesce e succo di limone. Tenete in caldo. In un pentolino mescolate l'aglio, lo zenzero, la salsa Shao Xing, la salsa chili, la salsa di soia e l'aceto di riso, portate ad ebollizione e versate sulle fette di melanzane. Condite i filetti di orata e rosolateli in olio d'oliva per 3 minuti per lato. Disponete i filetti di orata sui piatti, distribuitevi intorno le fette di melanzane e i pomodorini ciliegia e versatevi alcune gocce di salsa.

Water Bar Colette

Design: Arnaud Montigny | Owner: Marco

213, Rue Saint-Honoré | 75001 Paris | 1ère arrondissement
Phone: +33 1 55 35 33 93
www.colette.fr | contact@colette.fr
Metro: Tuileries, Pyramides
Opening hours: Mon–Sat 11 am to 7 pm
Average price: € 13
Cuisine: French, vegetarian
Special features: More than 100 different brands of water from around the world

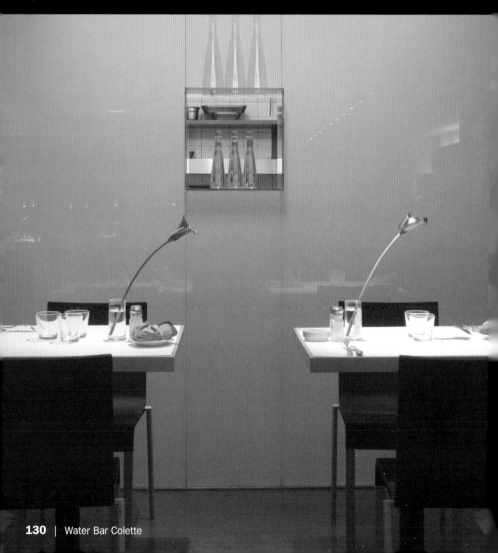

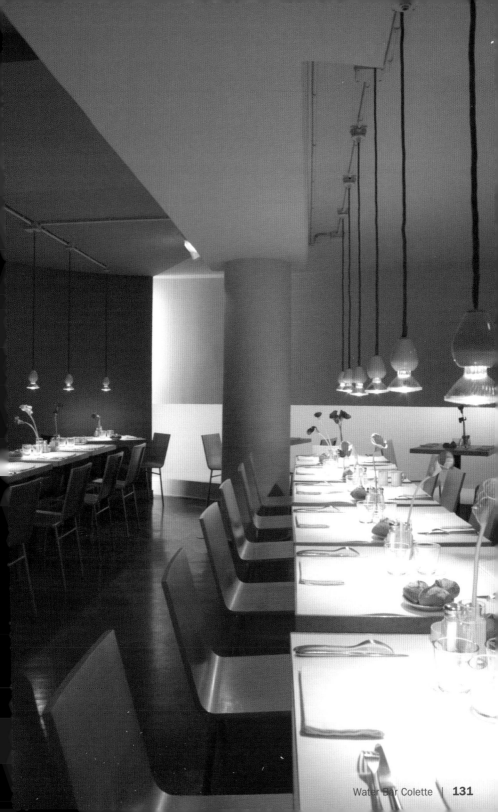

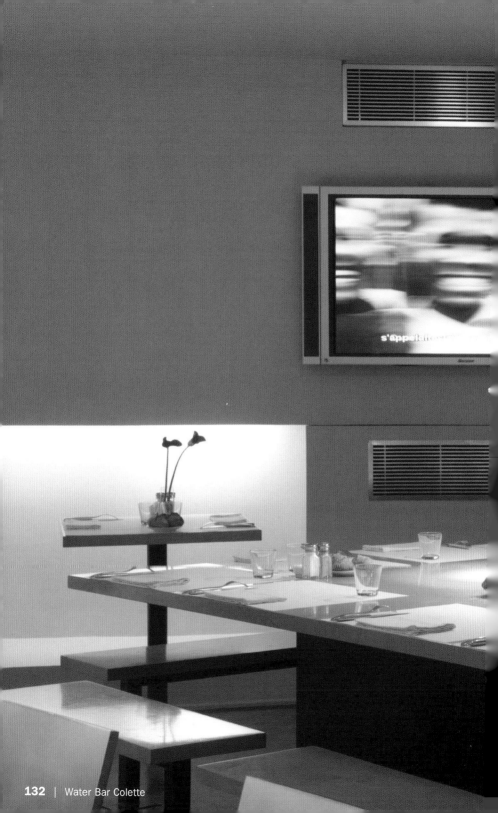

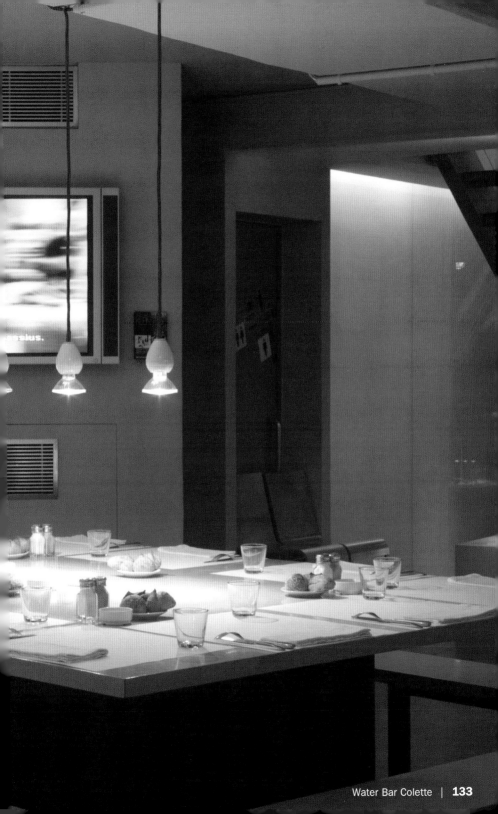

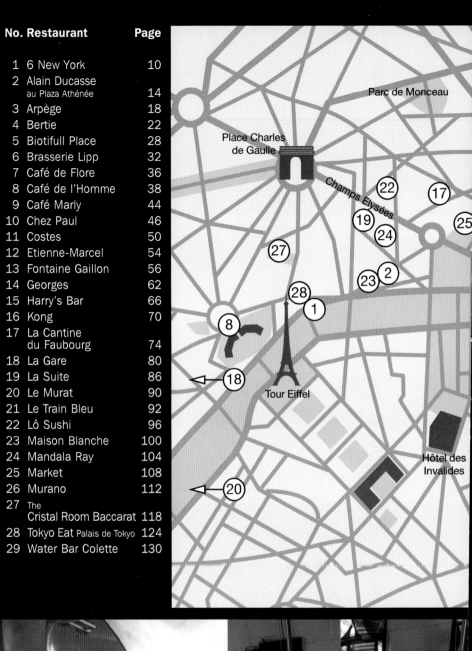

Parc de Monceau

Place Charles de Gaulle

Champs Elysées

Tour Eiffel

Hôtel des Invalides

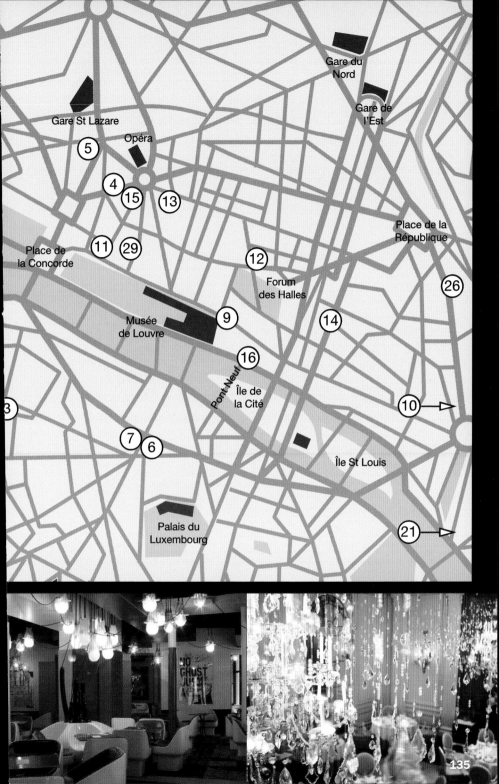

Gare du Nord

Gare de l'Est

Gare St Lazare

Opéra

⑤

④
⑮
⑬

Place de la République

Place de la Concorde

⑪ ㉙

⑫

Forum des Halles

㉖

Musée de Louvre

⑨

⑭

⑯

Pont Neuf

Île de la Cité

⑩ →

③

⑦ ⑥

Île St Louis

㉑ →

Palais du Luxembourg

Cool Restaurants

Size: 14 x 21.5 cm / 5 1/2 x 8 1/2 in.
136 pp, Flexicover
c. 130 color photographs
Text in English, German, French,
Spanish, Italian or (*) Dutch

Other titles in the same series:

Amsterdam
ISBN 3-8238-4588-8

Barcelona
ISBN 3-8238-4586-1

Berlin
ISBN 3-8238-4585-3

Brussels (*)
ISBN 3-8327-9065-9

Cape Town
ISBN 3-8327-9103-5

Chicago
ISBN 3-8327-9018-7

Cologne
ISBN 3-8327-9117-5

Côte d'Azur
ISBN 3-8327-9040-3

Frankfurt
ISBN 3-8237-9118-3

Hamburg
ISBN 3-8238-4599-3

Hong Kong
ISBN 3-8327-9111-6

Istanbul
ISBN 3-8327-9115-9

Las Vegas
ISBN 3-8327-9116-7

London 2nd edition
ISBN 3-8327-9131-0

Los Angeles
ISBN 3-8238-4589-6

Madrid
ISBN 3-8327-9029-2

Majorca/Ibiza
ISBN 3-8327-9113-2

Miami
ISBN 3-8327-9066-7

Milan
ISBN 3-8238-4587-X

Munich
ISBN 3-8327-9019-5

New York 2nd edition
ISBN 3-8327-9130-2

Prague
ISBN 3-8327-9068-3

Rome
ISBN 3-8327-9028-4

San Francisco
ISBN 3-8327-9067-5

Shanghai
ISBN 3-8327-9050-0

Sydney
ISBN 3-8327-9027-6

Tokyo
ISBN 3-8238-4590-X

Toscana
ISBN 3-8327-9102-7

Vienna
ISBN 3-8327-9020-9

Zurich
ISBN 3-8327-9069-1

To be published in the
same series:

Dubai
Copenhagen
Geneva

Moscow
Singapore
Stockholm

teNeues